DETROIT
FOOD

DETROIT FOOD

CONEY DOGS TO FARMERS MARKETS

BILL LOOMIS

PHOTOGRAPHY BY ANKUR DHOLAKIA

AMERICAN PALATE

Published by American Palate
A Division of The History Press
Charleston, SC 29403
www.historypress.net

First published 2014

Manufactured in the United States

978.1.60949.767.5

Library of Congress CIP data applied for.

Contents

Acknowledgements

I want to thank Adam Ferrell at The History Press for his support on this project, as well as Joe Gartrell, who initiated it and kept things going.

Thank you also to photographer Ankur Dholakia whose friendly advice and Detroit connections were very helpful. His experience and artistic vision with a camera were inspiring.

Also, thanks to my great friend of many years Bob Hart, who accompanied me to several of these eateries.

I want to thank so many friendly, generous people who are part of the food movement in Detroit. It is a pleasure and inspiration to see so many people doing good things. When smart people throw themselves into something, great things happen. It's happening in Detroit.

Finally, thanks to my wife, Janice, who even while swamped with work found time to listen to stories, help with editing and make tactful suggestions where things didn't work. And to my daughter, Natasha, who while young has excellent food sense, can already cook up a storm and is my favorite ice-skating partner at Campus Martius downtown.

–Bill Loomis

Acknowledgements

I would like to thank Bill Loomis for asking me to shoot pictures for his book and Adam Ferrell at The History Press for taking a chance on me and hiring me to do this project.

I would also like to thank the food entrepreneurs who are staking claim to the city and putting their own stamp on the Detroit food culture. You guys are an inspiring bunch, and I can see your passion through the food you make. Detroit needs more people like you.

Lastly, I would like to thank my wife, Ruchi, for being my art director and assistant and encouraging me finish the assignment.

—Ankur Dholakia

Introduction

Talking with chefs, restaurant owners, bartenders, farmers, sausage makers, waitresses, baristas and more, one is taken by their passion. It may be for the food or drinks they create, their adopted neighborhoods, the people with whom they work or even the history of the buildings in which they live. It is almost never the money. Even though making money is the bottom line, it is not what drives them. For many, it is a calling. It is a job that includes a sense of purpose, a deeply felt commitment. These are not people who would open a Dairy Queen in some quiet suburb. They do recognize the economic advantages of what they are doing, such as how cheap it is to start a restaurant or food business in Detroit compared to other cities. And they do understand the challenges and risks of Detroit; typically, the feeling among these entrepreneurs is that crime is real but never as bad as people from the suburbs think it is. The city is in such terrible shape that it can provide little to nothing in terms of support. For some businesses, like food trucks, it offered mostly bureaucratic difficulties. But these people are entrepreneurs who see something that others do not, and they are committed to that vision.

This book was written to give readers a glimpse at some of the people and their activities that are making today the most exciting time to be involved in the Detroit food scene. Some people own bakeries, some are urban farmers and some have saved old restaurants. Some hold "pop-up" events, like the very popular Tashmoo Biergarten in the small emerging neighborhood called West Village. Some of them, for the first time in their lives, talk about

finding not just a business but a "home" in Detroit. Several are quick to relay their credentials of growing up or living for a time in some neighborhood of Detroit, while others are from elsewhere—Arizona, Canada or closer, like Ann Arbor. Many are young, but not all—one of the owners of the Mercury Burger Bar is a retired Detroit cop. They bond with others like themselves; they eat at one another's places, promote and praise one another, share news and gossip, loan tools or trucks, look after one another and respect whatever each one is trying to do. Generosity is a part of this small community.

It is inspiring to meet and talk with these people, and when you listen to some of them, you realize why the city is making a comeback. It also explains why the national press and people from around the United States and the world are watching the city and visiting these places.

It's only food, but food can do that. Visit Detroit and see what the excitement is all about.

Detroit's Food Roots

Up from the Ashes

Speramus meliora; resurget cineribus
("We hope for better things; it will rise from the ashes").

A group of Detroit history lovers meets once a month in different Detroit bars to hear lectures and discussions on Detroit's history. With glasses raised high, they repeat Detroit's motto to start each meeting: one side of the room begins with half the motto, and then the other side responds with the second part: "We hope for better things…it will rise from the ashes."

Those words are the Detroit city motto, composed in Latin by Father Gabriel Richard right after the great fire of 1805 that leveled the city, which at the time was a village of fewer than two thousand people. Detroit's motto has an eerie relevance that is so spot on it sometimes makes people gasp when they first read it; how does a city motto written more than 220 years ago speak so directly to what Detroit is dealing with today?

After any terrible disaster in which homes are burned down, destroyed, and family and friends possibly hurt or killed, the first things that put life onto the road to normalcy and the victims to begin thinking of "better things" are shelter and sharing something to eat, especially hot food. If one can eat, one can begin the heavy task of hauling off the charred, smoky wreckage and clearing space for rebuilding the future. Food heals. When one is offered good food that is locally made with knowledge and care, it brings back a love of life and a desire for "better things." Before you can raise up your city from destruction, you have to have the desire to do it and not just

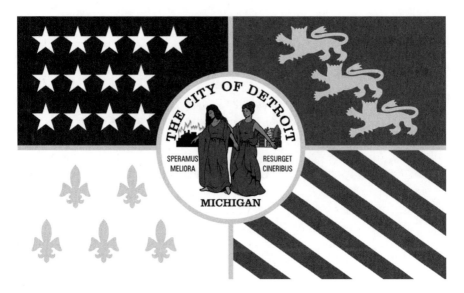

The flag of the City of Detroit, with the city motto.

walk away—to see a future that you hope can be better and not just the burned-out homes and destroyed lives. This is why Gabriel Richard's motto is so perfectly written and fitting.

The fire of 1805 occurred in June. All suffered. In 1804, Father Richard had built a new children's school, which was destroyed in the fire. In 1805, there was little medicine other than brandy; it was food people used to nourish the ailing: brandy with hot food, probably soup, poisson blanc (roast white fish so abundant in the Detroit River that it was many times free to be had) or other freshwater fish found in the Detroit River or Lake St. Clair, such as perch, walleye, sturgeon, lake trout or herring. It very well may have been *sagamite*, a common porridge of cornmeal and maple syrup shared by local Indian tribes. Wild game was everywhere and eaten daily, such as passenger pigeon, offered in a meat pie called *la tourtiere*. Roast turkey and wild ducks were common fare; the Detroit River continues to be a flyover for millions of migrating ducks, geese and other birds. Even the taste of beaver tail was highly prized. Maybe there was warm bread (Detroit's horrific fire was said to have been started by a careless baker at the village bakery).

Ironically, today, nearly two hundred years after Detroit's great fire, it has been a local bakery that has been key to rebuilding one neighborhood. In another part of the city, building a simple corner pub with good food doesn't seem like much, but it is also transforming an entire historic neighborhood one street at a time.

Avalon Bakery

"Eat Well. Do Good."

For many years, the area of the city called Midtown was known as the Cass Corridor. Cass Avenue, which runs parallel to the main thoroughfare Woodward, was then a gritty, narrow street of burned-out buildings, vacant lots, prostitutes and heavy drug and gun violence. It was considered one of the most dangerous streets in Detroit, thereby qualifying as one of the worst streets in the country—not really a place to start an artisan bakery offering 100 percent organic flour, but that's what happened in June 1997 when Avalon International Breads opened for business.

For Avalon founders Jackie Victor and Ann Perrault, there seems to be no clear line between religion and baking bread. These two women, who were in their thirties when they began, saw something better on Cass Avenue. As they state on their website, "We saw the seeds of a transformation, with food growing on vacant land, small businesses filling unmet needs, artists thriving, and neighbors coming together to rebuild, renew and re-spirit the city from the ground up. And we loved the cultural heritage, legendary architecture, and beautiful international riverfront of our city. Most of all, we loved the incredible souls of Detroiters."

They raised $6,000 from friends and family who purchased vouchers for bread loaves. With support from family and benefactors, they converted a former art gallery with neither lighting nor plumbing into a full bakery, with a retail facility. Like other startups, they worked beside friends, family and volunteers on eighteen-hour shifts. Today, more than one thousand customers are served at Avalon daily from sunrise to sunset, seven days per week. Three trucks leave each morning, delivering to more than forty restaurants and markets in the region. At every turn, Avalon uses locally sourced ingredients—"local" meaning from local urban farms merely blocks away.

Avalon's mission has been clear and unwavering: "Eat Well. Do Good." Mission is sometimes all you've got in a neighborhood like the Cass Corridor, but the act of making bread and great baked goods every day is reality. Customers entering Avalon leave the streets of Detroit and find handwritten chalk boards, the smell of baked bread and cookies, the neatness of breads and baked goods displayed on racks and employees who seem dedicated to their love of this place. Voices, bake pans and noise—a constant radio, brimming with life.

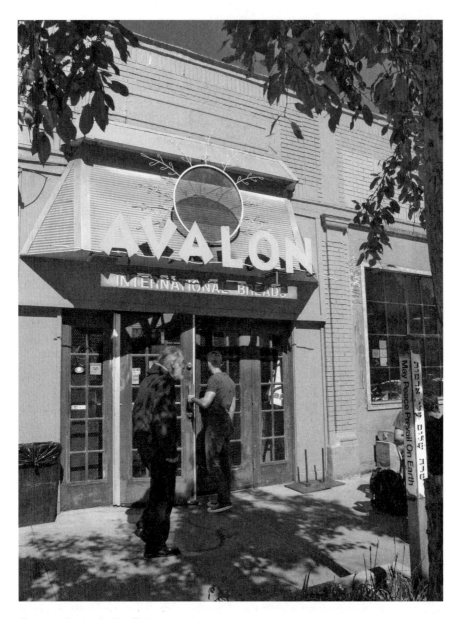

Entrance for the Avalon Bakery.

It is so crowded on some mornings that it is not only impossible to find a place to eat, but it's also almost impossible to move. Still, it has become one of Detroit's favorite bakeries. Avalon is a bustling place to be for professionals, city cops, college students and locals taking it all in. The

glass counter showcases the array of organic rolls, pastries, cookies and loaves one can choose from; racks behind display rows and rows of bread. The bakery offers creative deli sandwiches and desserts to satisfy the sweet tooth. There are seats outside, and except for busy mornings, generally seating is not an issue.

When you visit Avalon International Breads, you must try an absolutely fresh cookie. Bread flavors include a very popular Greektown olive and scallion dill bread and chocolate-filled bread, supposedly good for hangovers. Seasonal favorites include orange cranberry bread and a holiday stollen that alone justifies a trip to Detroit.

WOODBRIDGE PUB

The neighborhood of Woodbridge in Detroit is small but beautiful. It is one of Detroit's oldest, with many Victorian homes of red brick built in the 1870s. The neighborhood is named for William Woodbridge, governor of Michigan in 1840–41, who owned a large farm on which much of the neighborhood was subsequently built. After his death in the mid-1800s, the land was divided into parcels. This is when the largest and most opulent housing was built, mostly on Trumbull Avenue, as well as on the corners of almost every block. By the turn of the century, many middle-income and working-class Detroiters had filled in the land with more moderate single-family and two-family homes. By the Depression of the 1930s, the inhabitants had changed to lower-income residents, and many landlords had divided two-family homes into tenements and rooming houses. Poverty then set in. And so goes an all-too-depressing pattern in Detroit's neighborhoods.

Jim Geary came to the neighborhood in 2001. He was born and raised on a farm in Salem, Michigan, and had no experiences in large cities. He claimed to have grown up on a family farm amid "lots of old stuff." He moved to Ann Arbor and worked for a coffee roaster with a chain of shops, setting up new shops and taking them down as they were regularly opening and closing. However, something was lacking in Ann Arbor—a certain attitude to which he couldn't relate. When he came to Detroit, and more specifically Woodbridge, there was an immediate connection. "I felt like I was home," he said.

In December 2006, he bought the building at a forgotten corner at Trumbull and Merrick Streets, which at the time was an abandoned

The Woodbridge Pub.

general store of sorts. It had been empty for twenty-five years. He began rehabilitating it with a plan for a restaurant. One feature that he was set on was large windows. He wanted light in the restaurant, and he wanted people to be able to see into the restaurant. This was a risk; crime was still high in the area, but he insisted that he did not want the feeling that crime was a determining issue or that the restaurant was a war bunker.

He brought in materials from other lost causes: the long oak bar of the Woodbridge Pub is from a church rail in Saginaw. An old wood-paneled walk-in cooler salvaged from a closed butcher in Hamtramck serves as a very soundproof restroom. Other features include the original flooring and a stamped tin ceiling.

Although he had absolutely no experience in the restaurant business, it became a cause for Jim, and he threw himself into the work. "I did a lot of market research," he said. While not a chef, he approves the menu, which is filled with extraordinary salads and a steak sandwich that is extremely tender and close to a beef filet. Like other restaurants in the city, he offers healthy options, such as black bean and white bean burgers. Some of his personal favorites include the Maui Maui burger. The restaurant does Sunday brunches, which are packed, and he has added Sunday night pizzas,

also very popular. Prices are low for food, and there is a respectable list of regional and craft beers, again on Jim's insistence.

Patrons come from everywhere: Wayne State University students and staff, after-hours theater patrons, hospital personnel and even suburbanites. Many of the latter say to him, "If we could only move this place to our town." Jim knows that this could never happen—it is the spirit of Woodbridge Pub and the neighborhood that drives him and his staff, which he calls his real "family."

Early on in the pub project, Jim realized the importance of the neighborhood to its success. As he said, "You cannot operate a business in a crime-ridden, litter-strewn setting."

The city offered nothing, so he took it on himself. "Who's gonna do this?" he asked himself. "I learned that the best help I could offer Detroit was to take care of my little corner myself. I take care of my street." He began by keeping the sidewalk at the pub cleaned from litter. He mowed the vacant lot across the street, eventually buying it to keep it cleaned; soon, others in the neighborhood turned it into a community garden. Jim shovels the snow not just at the restaurant but throughout the neighborhood as well. His restaurant staff members, who know Jim's commitment, go down the streets trimming trees of overhanging branches. "We take pride where we live."

It is not gentrification, he added. "The recession in the mid-2000s was actually a good thing. The neighborhood has a long history of diversification, economic and racial. While once an elite area—the home of Ty Cobb, George Booth and others—it fell into neglect during the depression, and many homes were subdivided for workers, later for Wayne State University students. The recession of 2000 slowed down the money that drives up home prices and drives many people out of the area…This didn't happen."

While the restaurant is a success, Jim continues to rehab houses. Bringing to life this neighborhood is a personal mission. It drives him. The crime problem has improved, but the fear of crime is a suburban mindset, Jim claimed. While there is crime, he and others don't think of it continually. "You know, there are neighborhoods that are crime-ridden, but that doesn't mean all neighborhoods are crime-ridden. If something happens to people in the suburbs, they ask, 'Why did this happen to me?' whereas, people living in the city typically think, 'Why was I so dumb to allow this to happen?'"

Jim sees no need to expand, but he would like to see other stores open on Trumbull. With his drive, they will.

Neighborhoods and Their Food

Detroit is returning to life neighborhood by neighborhood. With a city government that is broken and unable to provide much of anything, it is individuals who are joining together, street by street in different neighborhoods, to rebuild, take risks and make things happen. In some cases, like downtown, they bring in a lot of money, but for most, it is pure spirit and drive.

Detroit is vast and sprawling. Each neighborhood is distinct, with a unique history, people and food ways. Over the last five years, change has been coming fast and furious, with restaurants, markets, food makers, farmers and building restorers leading the way. This chapter highlights a few of the key areas of the city that are seeing exciting changes after years of neglect and abuse.

DOWNTOWN DETROIT: FINDING A PAST, SEEING A FUTURE

Downtown Detroit is quickly becoming a hotbed for both entrepreneurs and entrepreneurial companies.
—Dan Gilbert

Big investors have taken an interest in downtown, but nothing like Dan Gilbert, the founder and chairman of Quicken Loans. Gilbert now owns or controls more than thirty buildings downtown, 7.5 million square feet

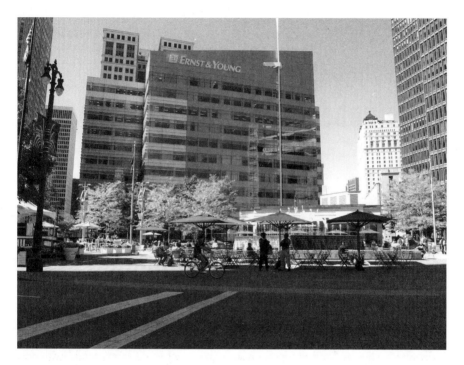

Downtown Detroit on a sunny day.

for his company and others like Chrysler Corporation. He also provides affordable space for startups and entrepreneurial activities through his M@dison Building. Along with exciting plans to transform blocks of buildings and street space downtown, Gilbert began an international competition for architectural concepts to develop the long-vacant Hudson Department store block. Gilbert is second only to General Motors in the number of buildings he owns in Detroit. It is believed that Gilbert's investment in Detroit is the largest investment for any individual or entity in Detroit's history, as well as one of the largest investments in any large American city by one organization.

Others who have been involved have been the Illich family, owners of Little Caesars Pizza, the Detroit Tigers, the Detroit Red Wings and Motor City Casino. Their company, Olympia Development, has long invested in Detroit, with triumphs such as Comerica Park and the Fox Theatre. Now Olympia Development continues building as it begins a $600 million coliseum as a new home for the Detroit Red Wings adjacent to downtown.

Small companies are also getting into the act, with firms like Mindfield USA, a tradeshow and promotional technology company in Detroit.

Owned by three ambitious Detroiters—Tom Carleton, David Carleton and Sean Emery—Mindfield has bought one of Detroit's historically unique buildings, the castle-shaped Grand Army of the Republic (GAR) building on the western edge of downtown, and is renovating it for office space and rental income.

As a result of all these changes, new residents are pouring into Detroit and snapping up the assortment of new lofts, apartments and condos; some organizations are offering financial incentives for employees to locate in Detroit and are getting hundreds of takers. Downtown Detroit is now home to about 10,000 residents and hosts 80,500 downtown workers, who make up about one-fifth of the city's total employment; 9,200 are Quicken Loan employees. Rents are rising. By the summer of 2013, residential occupancy rates were reported at 99 percent; developers cannot rehabilitate living space fast enough.

In the summer, thousands of young interns from Quicken Loans, DTE, Blue Cross, General Motors and other smaller companies swarm downtown on a daily basis. They come from across the country to work and play downtown. In the summer, downtown's center park Campus Martius is been turned into a beach with truckloads of sand for people to play volleyball; lounge on beach chairs; sip drinks at a tiki bar; listen to live bands; and munch on pizza, macaroni and cheese and French fries from brightly colored food stands and food trucks at Cadillac Square. As the *Detroit News* reported on July 8, 2013, the number of interns downtown has grown from a few hundred five years ago to thousands today.

The biggest numbers by far come from Detroit-based home lender Quicken Loans. Dan Gilbert said that the company is employing 1,175 interns in 2013 from 157 colleges and universities across the country. In 2011, the company had only 250 interns. This year, Gilbert said that Quicken received more than 18,500 applications.

DETROIT'S CENTER: CAMPUS MARTIUS

There's a massive, wildfire interest in Detroit. Detroit sells.
—Dan Gilbert

In 2000, Mayor Dennis Archer, city council and corporate leaders decided to rebuild the park with an ice-skating rink modeled on New York City's Rockefeller Center. (The Campus Martius ice rink is actually larger than

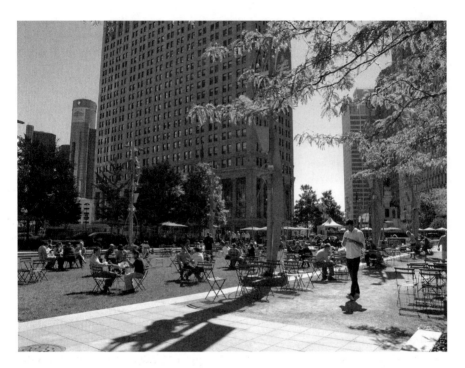

Campus Martius Park, downtown Detroit.

the rink in New York City.) Construction was completed in 2004. Since that time, the park has become the community gathering place for its immediate downtown neighborhood and for others from all over southeast Michigan.

During the holiday season, a sixty-foot Holiday Tree tops the Woodward Fountain. Campus Martius Park is the home of the annual Motown Winter Blast, an event that has drawn more than 450,000 people to the downtown area every year. In August, the park is filled with the sounds of the Detroit Jazz Festival, and throughout the season, the public enjoys free movies in the evening. In 2010, the American Planning Association designated Campus Martius Park as one of ten "Great Public Spaces" under the organization's Great Places in America program.

Occasionally, Campus Martius Park is actually quiet. Campus Martius has been described as a cool, green gem in the center of Detroit off Woodward Avenue. When you sit in the park listening to the splashing Woodward fountain in summer or watching skaters having fun in winter, you feel like you are in the very heart of Detroit. You are engulfed in towering buildings like the historic Penobscot Building, the contemporary Compuware and Quicken Loans Headquarters and the green glass façade of the Kennedy

Square Building. Along with the grass of the park, the magnificent Art Deco skyscrapers seem to keep down the city noise, giving you the feel of sitting at the bottom of a deep canyon. The park has serenity to it.

The Fountain Bistro is a small restaurant on the park, with its full glass façade accented with metal and stone. It offers panoramic views of the entire park. The sweet, intimate bistro sits next to the park fountain; during warm months outside, patio tables stretch to the fountain's edge. The fountain provides a backdrop that is both beautiful and soothing as one sips wine or dines on French-inspired dishes, such as mussels in a Dijon saffron sauce. In summer, the park offers free movies or live performances, while in winter, families or school buses with children come downtown for public ice-skating. It all makes for a great winter afternoon in Detroit to finish at the bistro with a light meal or dinner watching the skaters or the city's Christmas tree during the holidays.

At one end of the park is Detroit's "Point of Origin." All of the major avenues radiate out from this one spot; Seven Mile Road is seven miles north from the point of origin; Eight Mile is eight miles north. The Point of Origin is marked by a medallion embedded in the stone walkway. It is situated in the western point of the diamond surrounding the Woodward Fountain, just in front of the park's concession building.

Originally, Campus Martius was much bigger, but by the turn of the twentieth century, much was lost as increased traffic and commercial development crept in on it. Hart Plaza was to be the city's major center. The name Campus Martius is Latin, meaning "Field of Mars," an old Roman term for an open space dedicated to train the military; it was also used to gather, parade and drill soldiers. For instance, in 1861, colors were presented to the First Michigan Regiment at Campus Martius before it headed off to Civil War duty. The commanding sculpture at the southern tip of the park, where five principal thoroughfares convene, is called *Michigan Soldiers' and Sailors' Monument*, a civic sculpture to honor the veterans of the Civil War.

Come to Campus Martius. Sit and soak it all in.

DETROIT AND ITS CONEY ISLAND HOTDOGS

Detroit's unique Coney Island dog is a hotdog in natural casing with chopped onions, yellow mustard and a meaty chili-style sauce on a soft bun. Catsup is forbidden. The dogs are cheap, addictive and served by the thousands in

Coney Island restaurants found by the hundreds everywhere in southeast Michigan. Detroiters have been eating them for nearly one hundred years.

While the first Coney Island was not founded in downtown Detroit (it is believed to have come from Jackson, Michigan, in 1914), the American Coney Island and the Lafayette Coney Island restaurants on Lafayette Boulevard seem to be the start of Detroit and Michigan's love for these things. Detroiters swear that Coney Islands and the dining experience in these two age-old joints can't be matched by the hundreds of copycats throughout the city and suburbs (Coneys were never patented).

They are certainly old enough. The American Coney Island is one of the oldest (if not the oldest) businesses in downtown that is family owned and operated. The restaurant has remained at the same location for ninety-two years. The American Coney Island was founded in 1917 by Constantine "Gust" Keros, who immigrated to Detroit from Greece in 1903. The dogs were sold for a nickel and were so popular that he sent for his brother, William, back in Greece to help him. The story goes that Gust and William got into an argument soon after and split their restaurant into two parts— the present-day American Coney Island and the Lafayette Coney Island, which are side by side. The two have remained side by side for the past seventy years and are still owned by third-generation family members. Both are opened seven days a week, twenty-four hours a day on downtown streets where most stores are boarded shut.

While Lafayette has remained a diner with counter service and Formica tables unchanged (owner Bill Keros said that they have had the same cash register for forty years), it is a home for Coney purists, and the menu is simple: chili dogs, with or without raw onions; "loose burgers" or "looseys," which are unformed hamburger meat in a hotdog bun with mustard, onions and chili sauce; a bowl of chili, with or without beans; French fries; and, recently added, chili fries. (They seem to like to combine things.) On the other side, the American expanded in 1989 by buying an adjacent corner building and now offers a full-service restaurant with big, bright windows, whose menu now includes gyros, fish on Fridays, chicken, Greek salads, homemade soups and even baklava.

Of course, Detroiters are asked to take a stand on which place serves the best Coney Islands. Some get passionate about one or the other; diehard Lafayette fans have declared to have never stepped foot in the American and vice versa. Some have refused to taste the competition's Coneys or chili: the hotdogs are better at one place and the chili is better at the other. This rivalry has at times gone national. In November 1991, Grace

Keros appeared in a brief "sound bite" taken at the American Coney Island that was shown on *The Today Show* with Bryant Gumble. And in the fall of 2008, Grace faced off against Lafayette Coney Island on *The Today Show* with Al Roker. In 2010, Michael Symon—Food Network star, chef and owner of Detroit's Roast restaurant—staged a blind tasting at his restaurant for a show called *Food Feud*. That same year, the Travel Channel's *Food Wars* came here to settle the score once and for all. It held a blind taste test at Greektown's Old Shellelagh restaurant.

So, whose is better? Maybe it's time to come downtown and decide for yourself.

REBUILDING DOWNTOWN'S FOOD CULTURE

As downtown grows, Detroit's historic bars and restaurants grow along with it. In some cases, the new owners are trying to recapture the money and power lunches that were famous in many of the storied eateries. London Chop House was nationally famous, with regular visits from such notables as Julia Child. While it's not the same building or restaurant that Les Gruber owned for decades, it adheres to the London Chop House traditions and again is thriving. The same goes for seafood restaurant Joe Muir's, located in Detroit's Renaissance Center.

Others don't have the historic fame but do have the feel of the financial district. The newly renovated Buhl Bar is located in the Buhl Building, an Art Deco masterpiece. The Buhl Bar is a throwback to the time when each one of the buildings in the financial district had its own after-work cocktail bar. Names of past bars included the Money Tree, the Bull Market, King's Table and Brass Rail.

Café d'Mongo's Speakeasy is another quirky but hip place in a section of downtown called Capitol Park, once the home of Michigan's state capitol building. Café d'Mongo's is owned by Larry Mongo; the spot was described by the *New York Times* in 2011 as a "wonderfully eccentric speakeasy that feels more like a private party than a bar."

This bar/club reopened in 2007 and was a favorite haunt of hipsters for a while, but it has since broadened to include a much wider audience. Now on Friday and Saturday nights, you see everyone: professionals, locals, suburban tourists and more. It offers live jazz alternating with country music (basically everything). Drinks—such as the Detroit Brown, Faygo (Detroit's own soda

pop), whiskey, bitters and more—are cheap, starting at four bucks. Café d'Mongo's Speakeasy serves some highly respected soul food.

Elwood Bar and Grille is a sports bar. Detroit has always had its sports bars, and today is no different. Sitting in the shadow of Comerica Park and Ford Field, the Elwood Bar and Grille menu offers favorite classics. This is not a place to order a goat cheese soufflé, but when you need a burger, a sandwich, onion rings and a beer before or after a ballgame, you want to stop by the Elwood. The fun part of this place is the building itself. It is a classic Art Deco (Art Moderne style) diner that was designed by Detroit architect Charles Noble and built in 1936. In 1985, it was listed on the U.S. National Register of Historic Places.

REVIVING DETROIT'S SUPPER CLUB

Cliff Bell's may be the most beautifully restored restaurant and bar you will ever walk into. The *New York Times* noted, "This is the place to be in Detroit." You enter Cliff Bell's and feel immediately underdressed without a fedora or mink wrap; you glance around to check out the "swells." Maybe Fred Astaire stopped in for a drink. The club is luxuriously intimate, with mahogany and brass everywhere; warm, sophisticated lighting; Art Deco Moderne murals; and the well-known "bar side tables"—small, tray-sized settings for drinks or, in the old days, cigars and cigarettes. Several movie scenes have been filmed in this club.

The supper club was founded by John Clifford Bell, who moved to Detroit in his early teens at the turn of the century. At sixteen years old, his father, a socialist labor agitator and Irish saloonkeeper, put Cliff to work as a porter at his pub on John R Street, and so began Cliff Bell's legacy of providing entertainment to the city of Detroit. Prohibition led to Cliff Bell opening speakeasies under the radar, but it wasn't going to last. Bell opened his signature club, Cliff Bell's, on Park Avenue in 1935. It was a luxurious place at that time. He ran the club from 1935 until his retirement in 1958.

The building that houses Cliff Bell's is pure Detroit—built by the historic French Detroit Campau family and designed by Albert Kahn. Noted architect Charles Agree, who also designed the Wittier Hotel on the river, designed the club itself.

In 1985, the famous club closed and remained empty until late 2005, when renovation began on the long-shuttered club under a joint venture

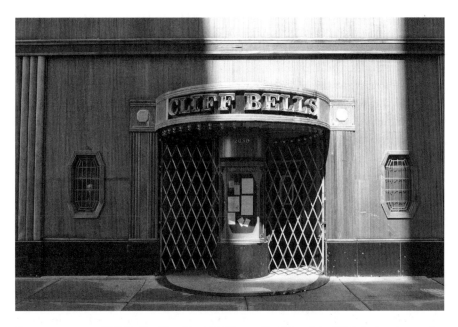

Front entrance to Cliff Bell's. The *New York Times* said of the club, "This is the place to be in Detroit."

of its current owners Paul Howard, Scott Lowell and Carolyn Howard. The club was considered unsalvageable by many who entered; water damage, mahogany walls covered in flat black paint (for a short while in the 1970s, it had reopened as the Cave, with a dungeon theme), reeking carpeting and a nearly destroyed bar. But in just six short months, the club was open again, thanks to the help of friends, neighbors and family members and the much-appreciated support of the building owners, Jerry and Lee Belanger.

Cliff Bell's is worth a visit if you only order a classic cocktail, but there's more to the restaurant than décor. Cliff Bell's soars in the night with some of the best jazz in the city, along with other forms of music, art events, poetry slams and more. Wednesday night is said to be the best. There is often no cover, but when there is one, it's usually only ten dollars.

The menu also thrills at Cliff Bell's. The kitchen, which is run by Matt Baldridge, seems inspired by the décor of the supper club, offering high-end French and American dishes, with a nod to Michigan.

CORKTOWN: DETROIT'S LITTLE VILLAGE

Corktown is Detroit's oldest neighborhood still in existence. (Detroit is actually 133 years older.) The roots of Corktown lie in the Irish potato famine of the 1840s. Much later, African Americans settled in, as well as emigrants from Malta and Poland. This was always a working-class neighborhood. You can feel the age of Corktown as you drive down the wide lanes of Michigan Avenue paved with bricks; Michigan Avenue was widened several times to accommodate streetcars. Many of the buildings are more than one hundred years old. Some of the little houses are called "Victorian cottages." It's common to see large Victorian homes, but these working-class bungalows, with their Victorian flourishes, are unique to Corktown. There were at one time more than one thousand homes in Corktown, but through neglect or city planning, there are fewer than three hundred left.

In years past, the only reason to go to Corktown was to see the Detroit Tigers play at the beloved Tiger Stadium, which sat at Michigan Avenue and Trumbull Street. Tiger Stadium closed in 1999 and was torn down in 2009. It was believed that its demolition would spell the end of Corktown; bars and restaurants survived on the fans' dollars. Vacant lots were encouraged for fan parking. The Michigan Central Station, the much-photographed iconic

Outside the Mercury Burger Bar on Michigan Avenue in Corktown.

wreck from Detroit's glory years, had been irrelevant for forty years and closed unnoticed in the 1980s. With these things passing, it was believed that Corktown was lost.

Then something happened. Musicians and artists found unused buildings that provided inexpensive studio space. They moved into cheap housing and bars selling dollar beers. Art, sculpture, new music and poetry were like shoots of new growth. Artists and others from around the world were hearing about Corktown and began moving in. This brought in architects and history lovers, who began restoring the old homes to their former charm. Soon after, buildings, streets and some of the parks came alive.

Urban farmers like Brother Nature began planting organic produce in vacant lots that had not seen vegetables in one hundred years. Coffee shops, bars and delis like Mudgies arrived. Slows Bar-B-Q opened in 2005 with so much attention from its beautiful building, rehabbed décor and great food that you might think it invented barbecued ribs. The owner, Phil Cooley, paid $40,000 for an abandoned building on Michigan Avenue and turned it into a multimillion-dollar business that serves about 250,000 people per year. Other entrepreneurs followed, like Astro Coffee, Mercury Burger Bar and Sugar House. There was and is a sense of community and home. New restaurants continue to open, and a whiskey distillery and new microbrewery are in the works.

Corktown is becoming what urban experts call a "destination." It's a walkable part of the city where parking is easy. It's still a favored place for live music. If you need your Irish fix, Corktown is the place for a pub crawl. Of course, the neighborhood swings every March for the Detroit St. Patrick's Day Parade. The bars and eateries fill up every April for the Tigers baseball home opener, even if their stadium was moved downtown. And if you prefer inexpensive, sociable, low-key hotel accommodations over a cookie-cutter chain hotel, you can find a bed in Hostel Detroit or Honor and Folly on Michigan Avenue. Finally and amazingly, the owners of the Michigan Central Station are working to restore it, but not for trains—just what for exactly is unknown, but it is a much-discussed mystery in Corktown's bars.

People who worked in Corktown when the Tigers played baseball there, like Dennis Fulton, a retired Detroit policeman, see Corktown differently. He's now a co-owner of the Mercury Burger Bar. As a cop, Dennis handled crowd control for twenty years or more at Tiger Stadium. As he explained, "There was no development in the neighborhood. Owners wanted the empty lots for parking." Dennis believes that the neighborhood shows more promise and optimism for the future and is better now than it was when the Tigers played there. "It's a mix of new and old."

FROM TORONTO TO DETROIT

It's small and was originally so close to the old Tiger Stadium on Michigan Avenue that it was called Left Field Deli.

"Urban food is locally sourced. Grown in the city. That's what we wanted to offer to customers. We do everything from scratch, including making our own mayo and mustard," said Jason Yates, co-owner and principal chef at Brooklyn Street Local. "Having locally sourced food is part of that as well."

The owners, Jason Yates and Deveri Gifford, are husband and wife. They are originally from Toronto and, for a few years, had been coming to Detroit regularly for the music scene. Deveri managed a restaurant in Toronto, and she and Jason had discussed starting their own someday. The problem was that Toronto is loaded with restaurants. "The restaurant business in Toronto is really competitive," Deveri explained. "It's a saturated market. It also takes a lot of capital to get started. Detroit does not." She and Jason stayed for a longer visit at the Hostel Detroit in Corktown and began looking around for a place to open. They snagged the Brooklyn Street Local for under $200,000, which included a fully equipped kitchen.

But it was more than low startup costs. "Toronto also does not have the urban farming that is common in Detroit," Deveri explained. When they say "local suppliers," they mean in the neighborhood, like Brother Nature. Other produce suppliers in the city include Rising Pheasant, Grown in Detroit and Greening of Detroit. "I can buy in small batches. I don't have to buy cases of this or that. My supplier has delivered to me a pound of basil on his bike!" She added, "It's very exciting. It's what urban food is all about."

The other big issue for this young couple is the support they have gotten since starting up. They've had a lot of press and a lot of local support from Corktown neighbors and others. "Detroit is loaded with independent entrepreneurs and startups," Deveri noted. "We like the pop-up food happenings and Detroit's Gypsy kitchens."

They brought with them poutine (pronounced *poo-teen*), the French Canadian comfort food that is basically French fries, beef gravy and cheese curds. But for Deveri and Jason, the equation also requires that the menu be healthy. One of their most popular breakfasts is the vegan pancakes. On weekends, Brooklyn Street Local offers an all-day brunch menu, with many people coming in the morning to eat and then heading over to Comerica Park to watch a Tigers game.

While small, they have no plans to expand, although they are working on offering outdoor seating, and Deveri added that "someday we want to convert the space in back to offer bocce ball."

Budget Gourmet Food with an East Detroit Flair

It's crowded at the Green Dot Stables for Wednesday lunch, and after Tigers games or events in the city, it is standing room only. The customers are in hospital scrubs, business suits, working uniforms and hipster garb, but there are others, such as an elderly couple playing pinochle as they do every Wednesday; they were the first customers at the Green Dot when it reopened. The reason they come is the relaxed, refurbished Detroit eatery with its kitschy 1971 horse racing décor, as well as for cheap artisan beer and a creative menu developed by a young chef trained at Le Cordon Bleu, Les Molnar. Molnar is friendly and engaging but focused, and he is imaginative with his offerings.

Molnar and restaurant owners Jacques and Christine Driscoll designed a menu based on small servings at small prices, almost like Spanish tapas or happy hour bar food. They serve them in cardboard French fry "boats" or small bowls. Even the extensive beer offerings are very affordable. But Molnar's menu is anything but bar food. He cooks for the food savvy but in a Detroit context, such as the old gut bomb sliders, the kind you found at Greene's Hamburgers or White Castle, brought home in white paper sacks. He even calls them "sliders." But his sliders include lamb tongue with hummus, a delicious Cuban with roasted pork butt ham and wonderful Korean kimchi with peanut butter. Of course, he admits that the best seller by far is the standard cheeseburger slider. Molnar loves to frame his sliders with the omnipresent white, pillowy, Wonderbread-style bun. To Molnar, it's just not a Detroit slider without that familiar bun for the ingredients. He also notes that a fancy brioche or sourdough only adds to the cost. It's about the ingredients, not the bun. And word has gotten out. According to Jacques Driscoll, Green Dot Stables serves six to seven hundred customers on busy days and has sold more than 100,000 sliders since opening in March 2012.

The twenty-eight-year-old executive chef was born in Detroit to a mother who was 100 percent Polish and a father who was 100 percent Hungarian. He was raised in Allen Park. He finished high school and attended Henry Ford Community College. Then, in 2003–4, he decided that food was his

love, so he moved to Chicago to study at Le Cordon Bleu. He handled charcuterie at Juicy Wine Bar, did a stint at the Paramount Room in Chicago and was even a personal chef in Madison, Wisconsin, but Detroit was calling. Molnar's quintessential east Detroit heritage works its way into his creativity as well. He offers a bologna-grilled onion slider, chicken paprikash soup and a traditional Hungarian chilled cherry soup. Molnar would like to focus even more on central European cuisine with its stews and soups but update the colors and flavors.

For Les Molnar, Detroit food is honest and hardworking; it's also not New York or Chicago. It is "not defined"; it's in a state of change and challenging. Like the city itself, no one is quite sure where it will be in five or ten years. "Keep Detroit Detroit," Molnar says. Like others in the food business, he has returned to the city with ideas and experiences that he's ready to share.

DETROIT'S ROMAN COLISEUM: MICHIGAN CENTRAL STATION

When you are sitting in the courtyard outside at the Mercury Burger Bar having lunch, or looking out the window of Slows Bar-B-Q or anywhere in Corktown or Southwest Detroit, the towering wreck of the Michigan Central Station has an almost hypnotic hold on your attention. It can feel like eating beside the Coliseum in Rome—the immense size of it; the sunlight beaming through windows with no glass; and the crumbling stone, rust, graffiti and dripping water. The monumental structure stands like a gigantic grave marker at the foot of grassy Roosevelt Park. For seventy-five years, the station served Detroiters, and now some see it as a singular symbol of Detroit's decline.

On the other hand, the Motor City has been a car-friendly city for nearly one hundred years, and the enormous station on the outskirts of downtown lost its appeal as interest in train travel waned. Some speculate that the reason it still stands is that there has never been enough money or reason to tear it down. But with the return of interest in Corktown, the building is undergoing restoration. The damage is severe, and the process is slow, but the owners have pledged to restore the old beauty. The building is of the Beaux Arts classical style of architecture, well represented in Detroit. It was designed by the Warren and Wetmore, Reed and Stem firms, which also designed New York City's Grand Central Terminal. It stands sixteen stories high and has five hundred

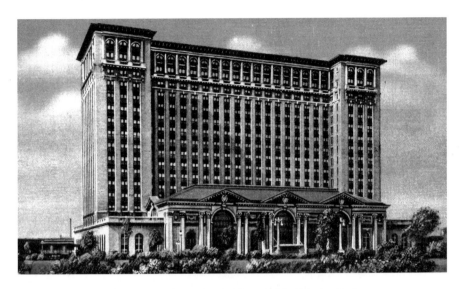

Postcard of Michigan Central Railway Station from 1925. *Author's collection.*

offices. When it opened in 1913, streetcars and the interurban dropped off passengers at the east end of the building, while taxis and private autos took the west end. At the beginning of World War I, the peak of rail travel in the United States, more than two hundred trains left the station each day, and lines would stretch from the boarding gates to the main entrance. In the 1940s, more than four thousand passengers a day used the station and more than three thousand people worked in its office tower.

One stepped off the train onto the glass-covered platform, through a gate and then up an incline to enter the main waiting room, which was breathtaking. It is 230 feet long and 95 feet across. It has an arched ceiling 76 feet high, roughly five stories. An article from the *Detroit Free Press* on December 31, 1913, described the interior:

> [A]*t the entrance are bronze finished and mahogany trimmed doors, and the waiting room itself is of cream colored brick finished in marble, with the arch decorated to harmonize. There are fourteen marble pillars set against the walls…there are four square pillars that give a sense of grandeur…in addition there are 10 columns of dark marble…In the main room there are twenty four hard wood and mahogany finished benches for the convenience of the passengers. The lighting scheme is such that the main room is brilliant at all times. Windows of unusual height serve on the bright days, and they*

are supplemented by 16 bright clusters set in bronze and resembling a pear in shape hanging from the high arched ceiling.

Ten ticket windows faced the concourse. Off the waiting room was a smoking room for men, a reading room for women, a taxi gallery, a full-service restaurant, a baggage room, restrooms, a flower shop, a manicurist, a café, a lunch counter, a cigar stand, a tearoom, a lounge, a drugstore, a first-aid station and a newsstand purported to be the biggest in the country. The innovative, electrically lighted bulletin board replaced the time-honored "caller," who, as the *Free Press* noted, "spoke a language of his own."

As the article concluded: "Every thing moves as smoothly as possible and one of the greatest needs of one of the greatest cities has been realized."

A DETROIT COP FROM TIGER STADIUM SEES CORKTOWN ANEW

The co-owner of the Mercury Burger and Bar, Dennis Fulton, began converting the Mercury from a coffee shop to his restaurant with a few others. He has been linked with Corktown for many years. Fulton was a Detroit police officer whose beat included Tiger Stadium at Michigan and Trumbull for nine years. He saved the exterior sign, as it was the original Mercury Bar's sign. In earlier times, the restaurant was a favorite for soldiers who rode the train from Chicago to New York, stopping over in Detroit. The train they rode on was called the Mercury. Soldiers spent the night at the adjacent Roosevelt Hotel, which is currently being turned into condominiums, and would eat at the restaurant.

Fulton is excited about the changes happening in Corktown. He claims that Corktown is livelier now than it was back then. Art galleries and coffee shops are opening, condos are full and restaurants and bars are drawing people to Corktown, so much so that Fulton is planning a second Italian restaurant down the road. "The key to success in this business is to find your niche," he said.

And it shows at the Mercury Burger Bar. Two of the most popular selections are the "Juicy," with cheese inside the burger, and the "S.W. [Southwest] Detroit," which includes a burger topped with a chorizo slider, jalapeños, Munster cheese, tortilla strips, avocado and zanahorias (pickled spiced carrots), with salsa on the side. (The inspiration for the

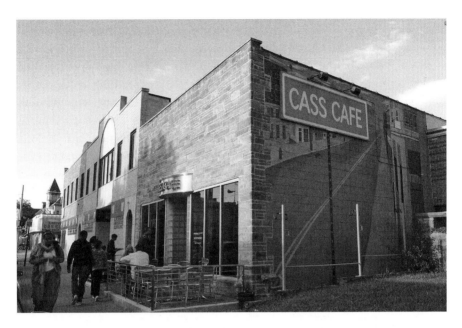

The Cass Café, located in Midtown, Detroit.

burger is because Southwest Detroit is home to Mexicantown, just west of Corktown.)

The Mercury is open seven days a week until two o'clock in the morning, and it's not unusual for a party of sixty people to show up after midnight, all very hungry. The late-night menu includes sliders, tater tots, whiskey, Michigan beer, pickles, crackers and moon pie. The late-night menu also states the "rules":

- *Be nice*
- *Over tip*
- *Dogs and butts welcome in Biergarten*
- *Just behave!*

The lunch crowd includes businesspeople, locals and parents with children. Most days it's packed. It's easy to see why. The food is traditional diner fare but exceptionally good. Some patrons said that their burgers are the best they have ever had. Very soon the Mercury will be open for breakfast. The chef of Mercury is twenty-four-year-old Ariel Millan, and since the restaurant opened in March 2012, he is packing them in. Ariel

was originally from Michigan but moved to Scottsdale, Arizona, to attend culinary school at Le Cordon Bleu. He is learning that trends are beginning to reverse; young people who once fled Detroit and Michigan are returning to live in places like Corktown.

In the presence of the immense and abandoned central train station, the Mercury Bar stands at the corner of Michigan Avenue and Fourteenth Street. The Mercury's décor is cheerful and diner-esque, with a long wraparound counter surrounded by small tables and booths. Total seating is 70. A lower level holds 55, and an outside deck, called the "Biergarten," with incredible views of the train station soaring overhead, holds 120. The counter is covered with zinc, dotted with two hundred mercury dimes and embossed with the names of the people who helped get the restaurant going. All contractors and many of the cooks and waitstaff are locals; a big portion of the patrons at the Mercury are Corktown locals.

THE POWER OF CULTURE: MIDTOWN DETROIT

There have always been artists, hipsters, poets, beatniks and musicians in Midtown. Wayne State University has had students living in the area even when it was a lot rougher than it is today. In part, what engendered changes in Midtown was Wayne State University, Detroit Medical Center and other corporations and foundations deciding that they had to invest money and restore the neighborhoods, improve the police force and encourage people to live in Midtown. Midtown has benefited from more than $1.8 billion in investment since 2000 alone.

Sue Mosey is president of the nonprofit Midtown Detroit Inc. and has been president of the University Cultural Center Association (UCCA) in Detroit for twenty-four years. Projects that have been undertaken by the organization under her direction include public improvements such as new streetscapes and park development, greenway planning and construction and residential and commercial real estate development and management. While there are still vacant buildings and vacant land, "momentum" is a word that is used a lot.

In June 2013, Whole Foods Market opened its newest Michigan location at John R and Mack in the heart of Midtown. In any other city, a new Whole Foods opening, while welcomed, does not make the newspapers. It did in Detroit, and the grand opening on June 5 was greeted with marching bands,

speeches, food sampling and complete media coverage. For Whole Foods, the Midtown store was its first in an inner-city neighborhood, as stated on its website: "Whole Foods Market is incredibly excited to announce our newest store location in Michigan, which is located at John R and Mack in Midtown, Detroit, and opened on June 5. We are looking forward to being a part of the Detroit community and all the wonderful things that are happening in the City of Detroit."

While Sue Mosey believes that it will be ten to twenty years before Midtown is a "complete neighborhood," Whole Foods shows some doubters that the momentum people speak about in Midtown is no fantasy.

So what led up to Whole Foods opening in Midtown? Before the money, there was the courage, vision and dedication of artists, musicians, entrepreneurs, preservationists and countless individuals to see what others could not: run-down houses, stores, streets and empty lots with beauty and potential—people like Chuck Ray, who started the Cass Café in the mid-1990s; Ann Perrault and Jackie Victor of Avalon International Breads; and Paul Howard, who rehabs Detroit's forgotten restaurant jewels. And there are hundreds more who saved buildings, grew vegetables in vacant lots, started businesses, took risks, opened restaurants and helped others not for the money but because they felt the neighborhood needed it. Their spirit built a following that continues today. Few cities in the region can offer more than Midtown Detroit.

Midtown is Detroit's cultural center, with the magnificent white marble Detroit Institute of Arts and the main branch of the Detroit Public Library facing each other across Woodward Avenue. Beside the library is the Detroit Historical Museum. A few blocks to the east is the largest museum dedicated to the African American experience, the Charles Wright Museum of African American History. And on John R Street, kitty-corner to the Art Institute, is the Michigan Science Center. MOCAD is two blocks south. Behind the Art Institute is a lesser-known historic art club called the Scarab Club, a jewel of the New York Arts and Crafts movement from the early twentieth century. Adjacent to the Scarab Club is the College for Creative Studies. One can spend a month in just this corner of the city and never exhaust these offerings.

Once home to Ty Cobb, Charles Lindbergh and the Dodge brothers, Midtown combines Detroit history, culture and optimism for the future. In Midtown, you can walk to ten theaters, yoga studios, organic bakeries, bookstores, breweries and a new flagship store for Shinola, which sells high-end watches and bicycles that it makes right in Detroit. And there are more than forty restaurants, cafés, pizzerias, clubs, bars and grills.

The area is greening up as well. Recently funded and under development is the Midtown Loop, which will be a two-mile greenway trail for pedestrians and bicycles that will follow existing street patterns and serve as the central connector for the area. Eventually, the Midtown Loop will be linked to greenway initiatives in surrounding areas, providing a key component of a larger greenway network linking Midtown to Eastern Market and the Dequindre Cut on the east side that ends at the Detroit River near Belle Isle.

A Pioneer Still Doing It in Midtown

The Cass Café was voted by the *Detroit Metro Times* as having the Best Bar Art and being the Best Bar for Conversation and the Best Bar to Take Friends from New York.

The Cass Café is as much a gallery of contemporary art as it is an excellent restaurant and late-night bar. Paintings and sculpture are displayed on stark white walls. Some of the art is from Detroit and some from other cities. As in art galleries, Cass Café holds receptions for the artists, and the art on display is for sale.

The Cass Café was one of the early successes in the revitalization of Midtown, started in 1993 by Chuck Ray. Back then, Midtown was still called the "Cass Corridor," and Ray still sees it that way. Ray played football for Wayne State in the late '70s and liked the area. He found a building that was vacant storage and, with a partner, opened a restaurant. The restaurant has gone through changes over the years to find its current niche. Ray's first partner was Middle Eastern, so initially the restaurant featured Middle Eastern and vegetarian dishes, some of which carry on today, along with a house specialty that has remained a favorite for nineteen years: the café lentil burger, with lentils, walnuts, parmesan and other fresh ingredients.

Today, lunch and dinner are the draws, with a second floor that highlights the industrial roots of the building, giving the Cass Café the vibe of an artistic loft. "We get an artsy, intellectual crowd, and we try to accommodate that with our menu," Ray explained.

Museum of Contemporary Art and Design (MOCAD)

MOCAD sets out to create a genuine community of art.
—New York Times

The Museum of Contemporary Art and Design (MOCAD) is in the Cultural Center of Midtown on Woodward a few blocks from the Detroit Institute of Arts. Its first exhibit was held in 2006, but it has already drawn attention from around the world for the quality of its exhibits, its innovative building and its involvement with contemporary culture of all forms in Detroit.

MOCAD distinguishes itself from other museums by saying that it does not collect artwork; its focus, rather, is to display works, engage the public and provide space for events. It is housed in a twenty-two-thousand-square-foot building, a converted former auto dealership designed by architect Andrew Zago, who is from Detroit. The architecture is intentionally raw and unfinished; it is spacious and open, the floor of the museum still has remnants of the linoleum tile from the dealership and the outside of the building is marked with graffiti. The idea is to display art or provide a

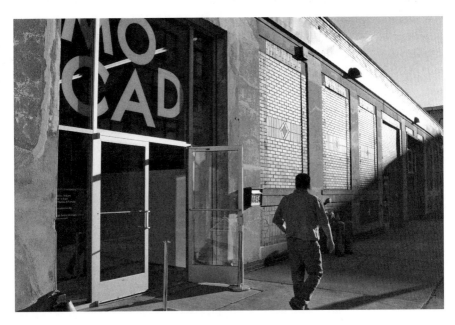

The Museum of Contemporary Art and Design (MOCAD) is in the Cultural Center of Midtown on Woodward Avenue.

space that incorporates the city, unlike other museums that display art in an abstract setting out of the context that may have inspired it.

In the short time since its doors opened, MOCAD has hosted musical, literary and artistic events; academic lectures; holiday events; kids' crafts; pop-up restaurants; and live music. Internationally acclaimed artists such as musicians Roy Ayers, Amp Fiddler, Dan Deacon's Round Robin, Michael Yonkers, Marlon Magas, Pink Reason and Roscoe Mitchell; writers like John Giorno and Bill Berkson; and performance artists such as Jody Oberfelder, Will Power and Pat Oleszko have all brought their work to MOCAD.

Even those people who bravely admit that contemporary art leaves them clueless have grown to love MOCAD for its renowned dance parties, especially on Halloween and Valentine's Day.

If you go to the Detroit Institute of Arts, give yourself time to check out MOCAD and experience the art that lives in Detroit now.

PALMER PARK

Palmer Park is an urban oasis composed of 296 acres of lawns and historic woodlands, a public golf course, tennis courts, hiking and biking trails, Lake Frances, a historic log cabin and some of the most valuable and diverse ecosystems in the state. Located at the northern end of Detroit west of Woodward Avenue, the area known collectively as Palmer Park has been a treasured nature park and recreation site for more than one hundred years.

The neighborhood and the park were once owned by Thomas Witherell Palmer, a former U.S. senator from Michigan who served in office during the 1880s. In 1897, Palmer donated 140 acres of land along Woodward Avenue to the city for use as a public park. This land formed the basis of Palmer Park. Palmer had inherited the land from his grandfather, Michigan territorial judge James Witherell. In 1885, the Palmers had a prominent architectural firm design a rustic log cabin–style summer house on the land. It was used by the Palmers as an escape from the city (the area was forested at the time) and a place to entertain guests. In 1897, Palmer donated it to the city along with the property. It remained as something of a museum and learning center until 1979, when the city moved the artifacts in the cabin to the Detroit Historical Museum and closed the cabin. A nonprofit organization, People for Palmer Park, and the City of Detroit reopened Palmer Park's historic 1800s log cabin. Nearly one thousand visitors toured

the structure in June 2013. This event drew the broad attention of local media and reconnected many old-timers and kids of all ages to early Detroit memories and hopes for Detroit's future.

This northern area of Detroit includes the Detroit Golf Club and neighborhoods that surround the main campus of the University of Detroit Mercy; Pilgrim Village; the Palmer Woods Historic District; and the Palmer Park Apartment Building Historic District, which is on the National Register of Historic Places.

Once considered home to the most sophisticated and beautiful apartments in the city, the Apartment District includes the work of some of Detroit's best architects. Built between 1924 and the 1950s, the apartments reflect exotic architecture in the Egyptian, Spanish, Venetian, Moorish, Tudor and Mediterranean styles, as well as Art Moderne and Georgian. Several of the apartment buildings have been completely renovated.

The Apartment District in the 1950s and 1960s was once a concentration of Detroit's gay population. The 2000s have brought increased investment to the neighborhood, with older homes and apartment buildings being restored.

1917 AMERICAN BISTRO

The 1917 American Bistro restaurant is located at the northern end of Detroit on Livernois Avenue, "the Avenue of Fashion," in a neighborhood called Sherwood Forest. The bistro, which was a former insurance office, was remodeled and opened in 2009 by Chef Don Studvent and his wife, Katrina Studvent. It is named after the year the Sherwood Forest subdivision—Detroit's version of Sherwood Forest—was established. Although the term "bistro" is used pretty loosely in America these days, 1917 seems close to the French concept. The food, which is American (hence the name), is reasonably priced and simple but well done; 1917 is family owned and operated, and it is linked into the neighborhood.

The narrow place is tastefully decorated in soft shades of yellow and warm beige, with natural lighting from the big front windows, track lights and hanging lamps; it has a homey yet sophisticated feel to it, enhanced by tasteful artwork from local artists on walls and hanging from the ceiling. Table seating is comfortably spaced under the high ceiling, and the place has a small, serene chic-ness about it. There is a second floor

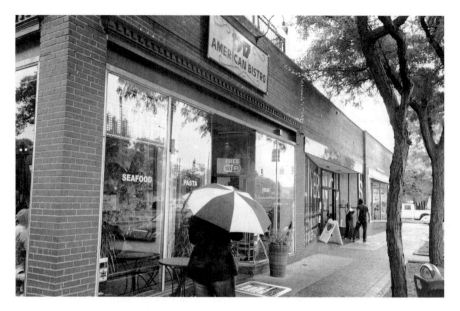

The 1917 American Bistro is located on the "Avenue of Fashion" in Palmer Park.

for additional seating, as well as a rooftop terrace that provides a relaxing view of Livernois Avenue.

While it does have a liquor license and feature wine tastings on some nights, 1917 also has a healthy juice bar that offers fruit smoothies and some creative hot drinks. At night, the bistro opens up for live entertainment, jazz, poetry readings and more.

THE LEGEND: BAKER'S KEYBOARD LOUNGE

It began in May 1934, when Chris Baker opened a beer and sandwich restaurant. His son, Clarence Baker, began to work for him at the age of fifteen. Five years later, Clarence took over the management of Baker's following his father's stroke in 1939. At that time, neither he nor anyone else knew that nearly eight decades later, it would claim to be the longest-running jazz club anywhere in the world.

In the late '30s, Clarence had installed himself as entertainment director and began booking solo pianists into Baker's. Soon the little jazz club was so popular that Clarence no longer served food as the principal means of

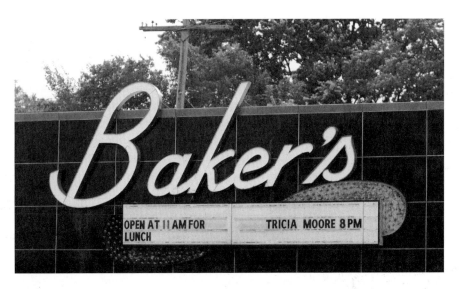

The legendary Baker's Keyboard Lounge.

support; he provided entertainment nightly. The room was enlarged, and Clarence changed the name to Baker's Keyboard Lounge. It soon showed off beautiful Art Deco furnishings, included a unique, piano-shaped bar painted with a keyboard motif, Art Deco–style paintings of European city landscapes by Harry Julian Carew, tilted mirrors that allow patrons to view the pianists' hands and its famous Steinway piano, which was selected and purchased in New York by Art Tatum for Clarence in the 1950s. By the '50s, Baker was booking jazz trios and quartets with such famous leads as Fats Waller, Meade Lux, Errol Garner, Art Tatum, Tommy Flanagan and George Shearing.

During this period, Baker's Keyboard Lounge had become a main link in the American jazz circuit. The period between the '50s and the '70s proved to be the club's golden era. The world of jazz had to stop at Baker's; some of the acts that played at Baker's included Dave Brubeck, John Coltrane, Miles Davis, Ella Fitzgerald, Oscar Peterson, Gene Krupa, Chick Corea, Cab Calloway and Betty Carter. There was also Gerry Mulligan, Sonny Stitt, Kenny Burrell, Barry Harris, Donald Byrd, Earl Klugh, Pepper Adams, George Shearing, Sarah Vaughan, Joe Williams, Maynard Ferguson, Woody Herman and the Modern Jazz Quartet. In short, most of the finest musicians in the world paid a visit to Baker's. In 1986, Baker's was designated a historic site by the Michigan State Historic Preservation Office.

While the trials of Baker's have been up and down over the last few decades, new owners have begun to revitalize Baker's, with noticeable improvements to the interior and exterior. The improvements include a new stage and a new sound system, new flooring, a new roof and updates to the kitchen. The new owners are also pursuing bringing in national acts and making continued updates to the interior and exterior of the building.

This is an icon of the Detroit music scene that with continued support will last one hundred years. It may not be as well known to the general public as Motown, but to those into high-quality jazz and jazz history, Baker's Keyboard Lounge should not be missed.

The Detroit River Comes Back to Life

There are only fourteen American Heritage Rivers, and the Detroit River was named to this group in 1998. It is in great company, including the Hudson, Mississippi and Rio Grande. However, it is the only river to also be named a Canadian Heritage River, in 2001. From its inception in the seventeenth century, Detroit has been connected to the Detroit River; throughout its history, Detroit was described as the "City on the Straits." The city was founded by the French to protect the "upper Great Lakes" from the British and generate money from fur trading. The early French families lived on "ribbon farms"—narrow land strips, all with water frontage, that stretched from ten miles below Detroit to five miles above it. Every French farmhouse was said to have its tiny boats and fishing nets drying near the front of the houses.

The Detroit River provided fish and other things besides. At one point, Detroit was famous for one food only: frog's legs. Gigantic bullfrogs up to nine pounds were pulled from the "flats," a huge marsh along Lake St. Clair. These monster frogs were sold at Detroit's farmers markets, the truly enormous ones proudly displayed. Detroit frog's legs coated with cracker crumbs and fried in butter were said to be President Grover Cleveland's favorite dish. Another favorite dish of the Detroit French was probably introduced to them by native tribes living along the river: muskrat. Today, muskrat roasts are still found during Lent in late winter.

The river continued to be loved as the Americans took control after the War of 1812. Migrants from New York and New England recorded their thoughts and impressions during the 1830s and 1840s as they took the

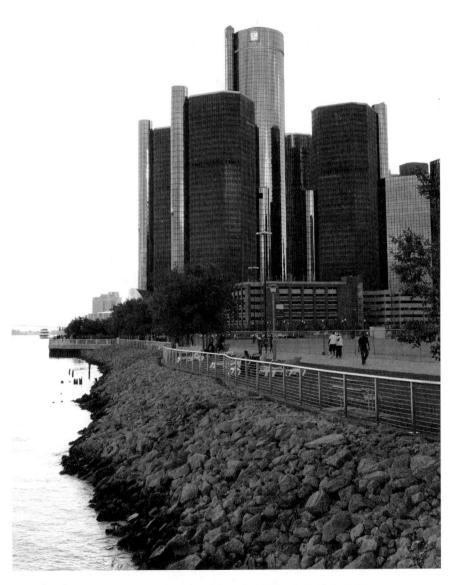

Detroit's General Motors headquarters and River Walk along the Detroit River.

majestic paddle-boat steamers from Buffalo to Detroit. One writer, George Bates, working for the *Detroit Free Press*, described the shoreline as his crowded steamboat, the *New York*, neared the docks of Detroit in the spring of 1833:

> *The sun had risen in all the gorgeous beauty of a May morning, and glinted and gilded the river, the shore, and the old French farm houses on both sides. The soft, south wind permeated everything on the land and the water, the peach and the pear trees, some then one hundred and fifty years old, were covered with blossoms. The air was laden with rich perfume…the log houses all newly whitewashed, neat, tidy, and surrounded by cackling geese, chattering ducks, squealing pigs, and lowing cattle, all of which could be heard on our deck, presented a scene of exquisite beauty, and a land so quaint, so unique, so beautiful that at once I was in love with it all.*

However, the attitude toward the Detroit River changed as the city became an industrial giant during the Civil War, when it manufactured armaments for the Union army. The river was a source of water needed by manufacturers of railroad cars, stoves, brass works, bicycles and, later, automobiles. Detroit was not unique in this; rivers or lakes situated near big cities from the late 1800s to after World War II were not considered to be places of recreation. They were shipping lanes for goods and people, sources of free water for manufacturing, water to drive power plants and sewers to carry off waste. The Michigan Central Railroad owned the Detroit shoreline and was more apt to have railroad tracks, lumberyards, warehouses and mountains of coal instead of pear trees and cackling geese. For generations of Detroiters, the river was no longer part of life in Detroit; the river was so polluted that no one considered being near it. It was simply where the city ended.

Changes occurred, none bigger than in 2003 when a coalition of public and private organizations—General Motors, Kresge Foundation and the City of Detroit—formed the Detroit Riverfront Conservancy. The organization cleaned up the shoreline and built what is known as the "River Walk." In 2013, the *Detroit Free Press* reported that the Detroit Riverfront Conservancy issued a new economic impact study showing the millions of dollars in benefits for the city from the operation of the River Walk. Among the findings of the study: annual spending by visitors, residents, employees and other operations along the riverfront is estimated at $43.7 million, while tax revenue generated by ongoing riverfront activity is estimated at $4.5 million annually.

Detroit's skyline and the Detroit River as seen from the shores of Belle Isle.

The River Walk is a three-mile stretch that runs from downtown to Belle Isle; eventually, it will be extended to become a five-and-a-half-mile walking and biking road from the Ambassador Bridge to Belle Isle. Along the promenade are two of the four planned pavilions opened to the public in 2007. Rivard Plaza, located at the foot of Rivard Street, features covered seating, a carousel, concessions and bike rentals. Richard Plaza, located in Gabriel Richard Park, features covered seating, concessions and a butterfly garden.

The success of this improvement has been undeniable. People are jogging, bicycling and strolling along this beautifully designed walkway and seeing the Detroit River as it once was for the first time.

THE WATER IS CLEANING UP

In 2010, the *Detroit News* reported, "From bald eagles to lake sturgeon, native wildlife is making a dramatic return in what might be considered the unlikeliest of places—the waters and shores of the Detroit River. Despite its spotty past and highly developed present, efforts to curb pollutants

have produced a resurgence visible this spring in birds, fish and animal populations that had long been absent from this integral 32-mile waterway in southeastern Michigan."

In its annual winter Detroit River bird count, Detroit Audubon and other groups recorded seeing more than two hundred bald eagles along the Detroit River and western end of Lake Erie. Bald eagles are nesting and producing young in seven locations along the Detroit River. Ospreys are nesting along the river for the first time since 1890. U.S. Fish and Wildlife is reporting that mayflies have returned to the Detroit River, which is a sign of improved water quality. Lake whitefish are spawning in the Detroit River for the first time since 1916.

Sturgeon is another fish that has not been seen in the Detroit River for decades. The *Detroit News* reported, "Over the last four decades, environmental laws have targeted and reduced all manner of pollutants that find their way into the river…As a result, species that once couldn't make a go of it here are increasing in numbers. One of those is the lake sturgeon. Now there are several spots where spawning is under way this spring."

The Detroit River is once again being considered a beautiful part of the city for more and more residents. Three companies now offer kayak rentals for exploring the river and the canals of Detroit's far eastside. And other events are opening up, such as Soiree on the Greenway, Yoga on the Riverfront and the Riverfront Walking Tour.

Bass, perch and walleye fishing have become competitive events. The Detroit River has an international reputation for its walleye fishery. It is estimated that walleye fishing alone brings in $1 million to the area's economy each spring.

Great Lakes fish have been mainstays on Detroit restaurant menus and in Detroit cookbooks. Fried perch, beer-battered smelt, pickled herring, lake trout, walleye, pike, pickerel, sturgeon and, of course, whitefish. In the nineteenth century, fishing companies along the river used huge seine nets, with horses on land pulling in the day's catch. Fishing companies harvested as much as thirty thousand whitefish per day. Salted whitefish sold for ten dollars a barrel and were shipped to New York to feed the workers as they dug the Erie Canal. The fisheries were operated on a cooperative basis, as were many family businesses. The French fishermen were a colorful lot, sitting beside their bunkhouse shanties in the autumn evenings, smoking clay pipes and watching the farmers across the river on the Canadian shore harvest crops. A campfire was always kept burning on the beach.

DETROIT'S *GREAT GATSBY* EXPERIENCE: THE DETROIT YACHT CLUB

*So we beat on, boats against the current, borne back ceaselessly
into the past.*
—*F. Scott Fitzgerald*, The Great Gatsby

If you seek an F. Scott Fitzgerald/Great Gatsby experience, you need go
no further than Belle Isle to find one of the oldest yacht clubs in the United
States, with the largest clubhouse in the world—the magnificent Detroit
Yacht Club (DYC). The DYC is considered to be among the most beautiful
yacht clubs ever built, with stunning views, Pewabic tiled fountains, two
ballrooms, museum-quality artwork throughout and enough racing awards
to merit a trophy room. But you don't need to own a yacht (or even a boat)
to join.

Nothing represents the opulent days of Detroit's golden years in the
1920s more than the DYC. While membership is down from its peak
of three thousand members when the building was completed, DYC is
enjoying a resurgence of members, particularly young people working
and living downtown.

The DYC was organized by Detroit sailing enthusiasts soon after the Civil
War ended in 1868. Jim Neumann, marketing and membership director of
the DYC, explained, "They had boats and a dock. They formed a 'syndicate'
or official organization to join in yacht races. Since yacht races invariably
conclude with drinks, they needed a building."

Neumann added, "The DYC has always been known for having a good
time." And from the very beginning, the Detroit Yacht Club was about boat
racing. This description is from the club's second official yacht race in July
1879, featured in the *Detroit Free Press*:

*Bang! Went the cannon…The sight was a magnificent one, as the
boats just far enough apart to prevent any collision, sailed on their
course. Every stitch of canvas that could be carried under the stiff and
freshening breeze was spread and the yachts keeled over until their rails
were nearly buried under the water, flying through the lake like huge birds
freed from a prison cage.*

A NEW NEIGHBORHOOD

The rediscovery of the river has spawned a resurgence of an old Detroit neighborhood called Rivertown Warehouse, with lofts, offices, stores, hotels and restaurants.

Globe Trading Company Building

To take advantage of the River Walk's popularity, the Michigan Department of Natural Resources (DNR) has begun to refurbish the Globe Trading Company Building. The hulk of a brick warehouse near the riverfront, which for decades served various industrial purposes, is being repurposed as a future "Outdoor Adventure and Discovery Center" for the DNR. The state is investing $12.8 million to turn the derelict building into a Great Lakes learning center. Once completed in 2014, the new development will have a climbing wall, play scape, classrooms and possibly an "interpretive forest."

Atwater Brewery

Rivertown is the home of Detroit's own Atwater Brewery, which is housed in a 1919 warehouse on Joseph Campau Street. Atwater Brewery was founded in March 1997 with the purpose of carrying on the glorious history of German breweries in Detroit. Atwater is serious about German lagers, to the point that it imported a brew house with brewing equipment from Germany so it can produce a variety of brands in the true style of traditional German lagers. Likewise, Atwater only uses malt and hops from Germany. Specialty ales are brewed with American hops. They combine a respect for tradition with creativity. All of this is resulting in the huge popularity of Atwater's beers in Detroit and around the region. The company slogan says it all: "We drink all we can and sell the rest."

Rattlesnake Club

Rivertown has become a popular destination for a leisurely evening stroll along the Detroit River followed by dinner. While there are plenty of restaurants to choose from, none has the reputation and staying power of

the Rattlesnake Club. The restaurant on the river is celebrating its twenty-fifth anniversary in 2013, and it continues to be one of the most appealing spots in town. The Rattlesnake Club first opened its doors in 1988 in Stroh's historic 300 River Place building, once home to Parke Davis & Company. Named by its founder, Jimmy Schmidt, to denote the energy of its kitchen, the Rattlesnake was one of the earliest eateries to promote the use of local and seasonable ingredients.

This is an upscale affair. The casually elegant, many-windowed space, with contemporary artwork displayed throughout the rooms, offers a list of elegant appetizers, entrées and desserts. Dishes that typify the Rattlesnake style include seared Maine diver sea scallops with roasted garlic and herb sabayon, toasted orzo and arugula salad and shallot-crusted rack of lamb, as well as prime New York strip steaks. The terrace, with its big pots of herbs and view of the river, is an especially popular place to dine on warm evenings, and a lighter menu of small plates is available in addition to the regular menu.

Detroit's Urban Farming

DETROIT: A CITY WITH LAND TO SPARE

Detroit is big, at least in land. It takes up 138 square miles of land for 700,000 people. By comparison, 600,000 people in Boston live in about 50 square miles. Detroit has lots of open space, and empty lots are everywhere. For some, the open fields, which once were neighborhoods, represent a city's final end. However, for many people, open spaces have generated an exciting new movement called urban agriculture or urban farms.

According to Rebecca Salminen Witt, president of Greening of Detroit, a nonprofit organization dedicated to improving the environment of Detroit, there are about fifteen thousand people in Detroit who can be called urban farmers. You see urban farms everywhere in Detroit: along the expressways, in empty lots, beside burned-out buildings and in community parks. Some restaurants, like Russell Street Deli in Eastern Market, get their herbs and vegetables from their own urban farms. Even in downtown Detroit, Compuware has an award-winning garden behind Lafayette Coney Island—a living beauty amid the towering buildings and traffic. The City of Detroit offers empty lots for people to farm for free, although they do have to pay for annual permits. Greening of Detroit provides the tools, seeds, supplies and knowledge for people and neighborhoods to get started. Greening of Detroit's budget began at $250,000 and has grown to more than $6 million through donations, corporate sponsorship and federal grants. People grow everything from vegetables to exotic flowers and fruit

trees. They raise chickens and other animals. Witt knows of one cow on a farm in Detroit. (Keeping livestock in the city is not permitted.) Greening of Detroit will supply bees if you want to raise bees. Its goal is to get healthy vegetables to Detroiters and provide training for some who see a career path in gardening, farming and even marketing and selling their produce.

Urban farms are defined as being less than three acres in size. All the farming must be done by hand, as there are no tractors or machinery. Finally, they are organic. Most farms are grown by individuals from all walks of life: retirees, hipsters, families, schools and even religious organizations. Many are community-based, with neighbors volunteering to water and weed. While many consume what they grow, others like Compuware donate garden vegetables to various charities. A small percentage (about seventy to eighty farms in Greening of Detroit) are what Witt calls "market farms," which grow things to sell to restaurants, florists or at the Eastern Market. The demand for locally sourced organic produce is strong, so it allows some farms like Brother Nature Produce and Rising Pheasant Farms to make a living from their farming.

BROTHER NATURE

Brother Nature Produce was in the Greening of Detroit co-op, but it has been successful enough to go it alone. Brother Nature is owned by former teacher Greg Willerer. He farms about an acre in North Corktown off Rosa Parks Boulevard. In addition to Brother Nature, Willerer helped start a composting business called Detroit Dirt, which he says generated three hundred cubic yards of compost last year from restaurant, brewery and landscaper waste. Detroit Dirt also gets manure from a horse farm in River Rouge Park. Willerer has been at it for six years and, until recently, doubled the amount of growing space every year. He sells about two hundred pounds of exotic salad greens a week, much of it mizuna, and there are twenty-seven families in his CSA (Community Supported Agriculture) who get produce from him on a regular basis.

The city has concerns. There are still sixty thousand empty lots in the city, and the land is cheap, sometimes $300 for a lot (measuring thirty by sixty feet). There is a worry that a large company might come in and buy acres of land to farm. Hantz Farms, which grows hardwood trees, is an example. A State of Michigan "Right to Farm" law was passed to protect farmers from

complaints and pressures of subdivision developers to stop farming. For the City of Detroit, it could lose zoning rights for the city if large farms claim "Right to Farm." Witt explained that this is something that must be worked out at the state level.

In the meantime, urban farms continue to grow at about a 10 percent rate per year. Bigger organizations are getting involved, like Michigan State University. And a smiling Rebecca Witt sees things as all good. "Our goal is to get 51 percent of Detroiters veggies from organic urban farms. Everybody wins."

IN THE FIELDS WITH SINGING TREE GARDEN

Emily Brent is twenty-nine years old. She's co-owner of the urban farm Singing Tree Garden, an organic urban farm in Detroit's north side, in an area within Detroit called "Highland Park." The spring and summer of 2013 had a lot of rain, and the farm looks lush, but she apologizes for the weeds.

The farm is located on East Parkhurst Street, which was once residential but is now a street of empty, weed-choked lots. Emily's small house at the farm is one of the last houses standing on the block. At the end of the street is an abandoned public school that has now become a dump; the end of the street is blocked off with logs and scrap wood dropped by the trucks dumping trash, so to get to Singing Tree Garden, you need to drive the wrong way on Parkhurst, which is a one way street.

"We have ten lots," Emily explained. It is about an acre. She is tall, fit and tanned from gardening. "We grow all types of vegetables. We also own more lots—which my husband, Kevin, bought before we were married—that have ten-year-old fruit trees: apples, peaches, pears and apricots." She noted, "We sell at smaller markets like Gross Pointe. Eastern Market is too big and overwhelming for us." She added, "We also sell directly to restaurants, such as St. Cece's in Corktown."

As a strictly organic farm, weeds are a given. "Our biggest pests are flea beetles, but we also have rats. I keep them under control with cayenne pepper powder."

Emily was born and raised in Ann Arbor, which is about forty-five miles to the west. Her first acquaintance with organic produce was working at Whole Foods and with Ann Arbor's famous Zingerman's, where she was the

produce buyer. She dealt with local organic farms. She later became "chef special" and began cooking with locally grown produce, which she "fell in love with." But she wanted to get deeper into the local food movement and its beautiful organic produce. She added, "If I wanted to continue making my own great food, I'd need to get to the farms."

She used World Wide Opportunities on Organic Farms (WWOOF), a placement agency for international organic farms, to locate a French-speaking organic farm where she could volunteer. She decided to work at Les Jardin Lieveres (Garden of Rabbits) in Quebec, Canada, outside Ottawa.

"I had spent a year in France and wanted to keep my French language active so I decided to work at a farm in Quebec." But she missed home, so after a year, she decided to move to Detroit, where she met her future husband, Kevin, who is an arborist (a tree specialist). They were married in the summer of 2012 at the farm. Emily's farm represents about 10 percent of the couple's income; however, she pointed out that the farm also feeds them for many months a year, and given the price of organic produce, Singing Tree Garden is saving them $400 a month in grocery bills.

Emily's produce is beautiful. She points out lettuces, dill, chard and candy cane beets bulging from the soil. But beyond the challenges of urban farming, there are other forces that threaten the farm's continuance. The city is trying to consolidate residents and would like to move Singing Tree Garden off the vacant street. "They will give us 'blight tickets' for even minor things like a delivered pile of wood chips. We have to watch for them." She is also near the path of the new M-1 light rail system that has been funded to be built up Woodward Avenue. "We found out somebody has been buying up the empty lots on this street recently. So, we really don't know what's going to happen."

There is crime in the area. There are drug houses nearby and prostitutes at the end of Parkhurst, but in all, Emily keeps vigilant and believes that the vast majority of people in the area are courteous and good. She stays friendly and offers produce to neighbors who ask for it.

Emily Brent's idealism and her belief in people never leave her. "The people in the neighborhood are nice people—just really broke." She added, "If you put up fences and fight back the neighborhood, you will have problems. But if you stay friendly, offer people little jobs that ask for them, people will look after you too."

POTATO PATCH PINGREE

Detroit has a history of urban farming. The panic of 1893 and the depression that followed in 1894 had a severe effect on Detroit's financial and banking sectors. All manufacturing entities laid off workers, to the point that state census reports of the times estimated male labor force unemployment to be at 33 percent. Especially hard hit were the foreign-born, Polish and Germans, who were at 50 percent unemployed. Mobs threatened riots and looting.

It was in the second summer of the depression that Detroit's mayor, Hazen Pingree, initiated his original idea of urban farming, turning vacant land into garden plots. Since many of the foreign emigrants were not far removed from peasant farms, Pingree thought that they might take to raising their own food. He sold his prize horse at one-third of its worth to kick off the potato patch program and got access to farm 430 acres of city land.

In 1894, 3,000 families applied to work plots, but there was only money for 945. In the first year, those families grew $14,000 worth of produce, so much that there was a surplus. In 1895, enrollment to farm plots grew to 1,500 and more than 1,700 in 1896. The value of produce exceeded $30,000, more than the outlay of the city poverty commission.

It was an unquestionable success, and Pingree became a national hero. He spoke to two thousand people in New York City. The potato patch scheme was copied in such cities as New York, Boston, Chicago, Minneapolis, Seattle and Denver.

Detroit mayor Hazen Pingree began his urban farm experiment in 1894 during a severe economic depression. Pingree's success with urban farms made him a nationally famous figure. He was known as "Potato Patch Pingree." *Library of Congress.*

Eastern Market

THREE HUNDRED YEARS OF FARMERS MARKETS IN DETROIT

Saturdays in Detroit mean that it's time to shop at the venerable and hugely popular Eastern Market, a destination drawing tens of thousands of marketers for more than 125 years. The market only seems to grow in popularity year after year. The nation's largest public market, Eastern Market features produce, flowers and prepared goods from 250 regional growers and vendors, as well as surrounding blocks filled with a bakery, meat market, a sausage maker, an award-winning pizzeria, an open pit barbecue with the sounds of Motown karaoke, a seafood store, a wine shop, specialty gourmet shops, America's "oldest corned beef specialist," a halal slaughterhouse and numerous restaurants. The Eastern Market now draws forty to fifty thousand people on Saturdays and brings in $24 million in sales annually.

Eastern Market is the descendant of a long history of Detroit farmers markets that began in the early 1700s and blossomed in the 1800s. In the earliest markets, you could find French farmers and their wives selling garden produce, Ottawa Indians offering maple sugar and Canadian voyageurs hawking animal pelts to shoppers. The third ordinance of the City of Detroit when it was incorporated in 1802 was to establish a farmers market. (The first ordinance concerned fires; the second established the weight of a loaf of bread.) In one of the very early markets, near Jefferson Avenue,

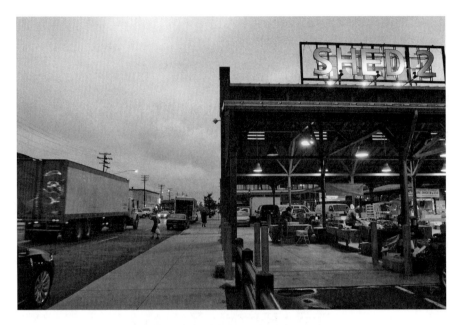

Detroit's beloved Eastern Market at daybreak on Saturday, "market day."

the sheriff erected a whipping post to help keep order. Before it was today's Eastern Market, the area housed a cemetery and then a prison.

Eastern Market began as a hay market and wood yard, while produce, meat and other items were sold at the "Central Market" located at Cadillac Square downtown. In a push to beautify downtown, many complained about the ramshackle building and chaos of farmers, so in 1891, the downtown market was moved to the Eastern Market. A local historian and tour guide at Eastern Market, Dick Rubens, explained that "every Saturday, farmers, teamsters and customers arrived on 180,000 horses, each leaving thirty pounds of manure and six gallons of urine. Think about that the next time you complain about auto pollution!"

In 1899, Detroit ladies arrived at Eastern Market in coaches and carriages, their drivers in livery. Ten years later, the ladies motored themselves to market in a Detroit Electric Vehicle or were chauffeured. The poor did shop there as well, but they walked to the market, which did business all day and into the night.

By 1924, Eastern Market was said to be the largest farmers market in the world, with more than $5 million worth of produce changing hands. "Produce is now trucked in from a radius of 50 miles and sometimes

more than 100," the *Detroit News* reported at that time. "Celery from Kalamazoo, fruit from Benton Harbor, greenhouse products from around Toledo, berries from the Erie section near Toledo, truck crops from Canada are frequent sights."

Eastern Market was declared a historic area in 1977 by the State of Michigan Historical Commission. Many of the original buildings are still in operation today.

So Big It Needs a Tour

Eastern Market is organized into a series of towering "sheds," with sheds 2 and 3 seeing the most action on Saturdays. But other neighboring buildings also line the streets of the Eastern Market, some of which date to the turn of the century. Several of the old buildings were former breweries, such as the Detroit Brewing Company and E & B Brewing, and many proudly display beautiful tile mosaics. Artists from around the world come to paint their masterpieces on the venerable brick walls of the buildings in and around the market.

Other companies have established retail stores, such as Hurt Cheese, which has been in business at the market for more than one hundred years. Rocky's Peanuts began with $850 as a peanut vendor at Tiger Stadium and then opened a storefront at Eastern Market. He built the business into a wholesale distributor of all kinds of food for southeast Michigan.

On Gratiot Avenue, which borders the market, is the Gratiot Central Market, a large indoor meat market, with its beautiful Victorian tiled white façade of cows; non-English-speaking new immigrants to Detroit had no problem understanding what was in the building when they saw that tiled front of animals. Down the street at the corner of Russell Street and Gratiot Avenue is Busy Bee Hardware, founded in 1918 and now run by the fourth generation of original owners. This is an active, busy hardware store, but with creaky flooring dating to 1924 and an original rope-pull elevator. Upstairs in storage is a treasure-trove of old goods, including mint-condition wood-burning stoves that never sold and are still in their original crates.

Many of the buildings along Gratiot have been refurbished and proudly display their original and stunning Art Deco façades. They now offer new apartments, lofts, restaurants and art galleries. As the cashier at the Busy Bee Hardware said, "Everybody is feeling more optimistic these days."

Eastern Market is divided into "sheds," large open-air structures.

The nonprofit organization Preservation Wayne offers "heritage tours" of Eastern Market that can last up to two hours. Many people who take the tour are young, such as Julie Atty, who works in Dearborn, and Kevin Robisher, newly arrived from California but now working and living in Detroit. For them, this is a brand-new world that goes on and on.

A new generation of foodies is bringing new ideas and great food into the market. Supino's Pizzeria offers hand-thrown thin-crust pizza based on Chef Dave Mancini's trips to his Italian family hometown of Supino. Supino's was voted best pizza in the city and has been drawing national attention. The Russell Street Deli has also received national attention from writers such as Mark Bittman of the *New York Times*, as well as a nod from Garrison Keillor. The green and yellow front of Russell Street Deli can't be missed, and the deli packs them in for soup, burgers, corned beef and other favorites. It also has its own station at the Detroit Lions' Ford Field.

BARBECUE AT EASTERN MARKET WITH JAZZ AND MORE

Eastern Market just isn't complete without the smell of barbecue, soul food and Motown karaoke. Bert's Market Place is on Russell Street. This is laidback, smoky fun. Patrons select their orders from a sandwich board menu and then sit at outside tables with their barbecued ribs, catfish, brisket, chicken, kielbasa and obscenely huge hamburgers. This is all done with Bert's award-winning sauce. Since it does not use a dry rub, the barbecue is not spicy, and there is just a touch of sweetness. Lemonade is freshly squeezed as you wait. As people eat, they relax and watch pit masters work an enormous grill and listen to Motown classics. It's become a market mainstay.

Bert's at night and in the off season is a jazz club, started by Bert Dearing in the 1980s. Dearing turned an empty warehouse into Bert's Warehouse, which is a huge space at the market for large productions and theater. On weekends, the Bert's Market Place Jazz Club fills up fast. This club showcases locals and amateur jazz talent from across the country; however, some of the nation's biggest talents have also shown up at Bert's, such as Wynton Marsalis, Branford Marsalis, B.B. King, Chaka Khan, Betty Carter, James Carter and even Boy George.

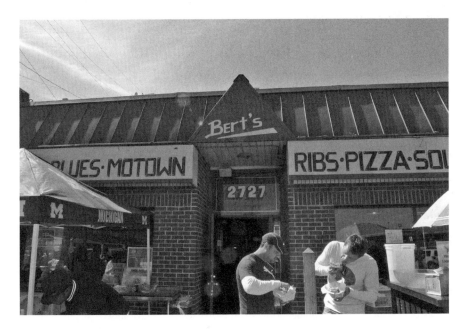

Bert's, an Eastern Market favorite.

Roma Café: Eastern Market's Grande Dame

Roma Café sits alone at the edge of Eastern Market. The small building with red and white striped awnings dates from the late 1880s, and today the restaurant holds on to a classic style with its low lighting, heavy carpets and intimate tables. The table service is formal, using older male waiters in uniforms that seem anachronistic. Roma Café was opened for business in February 1890 and is now Detroit's oldest restaurant. Dining at Roma Café brings to mind an era when Italian restaurants in Detroit or elsewhere in the Midwest were either pizza parlors or cliché-loaded "Eye-talian" tourist spaghetti escapes. That was true of the restaurants where the food was mediocre and customers knew no better. That has never been the Roma Café.

The restaurant began when the Marazza family opened their home as a boardinghouse for traveling farmers at Eastern Market. Mrs. Marazza served her boarders hot meals, and the reputation spread that the meals were very good. With some urging, Mrs. Marazza changed the house into a restaurant and called it the Roma Café. The business was sold in 1918 but has been held by the same family, the Sossi family, for three generations.

The Roma Café began by feeding farmers as they arrived at Eastern Market to sell their wares. It is now the oldest continuously operating restaurant in Detroit, with classic Italian cuisine. Roma Café was begun in the 1880s.

Jim Geary, owner of the Woodbridge Pub.

Detroit's famous Coney Island restaurants.

Detroit's downtown Coney Island restaurants.

Corktown, Detroit's oldest neighborhood.

Deveri Gifford, co-owner of Brooklyn Street Local in Corktown.

Brooklyn Street Local's order of Canadian comfort food poutine (fries, cheese curd and gravy).

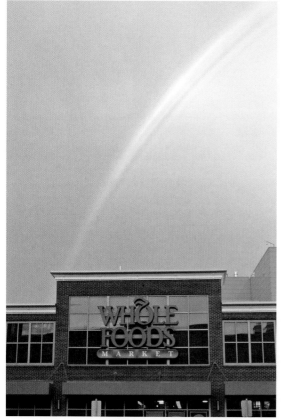

Above: Corktown restaurant Green Dot Stables, with Chef Les Molnar.

Left: Whole Foods in Midtown, Detroit.

Chickens on the march.

Greg Willerer of Brother Nature Produce.

Emily Brent, co-owner of Singing Tree Garden, located in Highland Park, Detroit.

Freshly harvested garlic at Singing Tree Garden.

Produce at Eastern Market.

A veggie melt from Russell Street Deli at Eastern Market.

Opposite: Entrance to Eastern Market on market day, as well as produce found there.

Eastern Market vegetables.

Will Branch, co-owner of Corridor Sausage, located at Detroit's Eastern Market.

Joe McClure stands with his signature product, a jar of McClure's Pickles. He and his brother, Bob, began their pickle business in Brooklyn, New York, but to expand, they moved the production to Detroit, where the McClure family is from.

Pickles in process at McClure's Pickles.

A Michigan draft craft beer at Ford Field for the Detroit Lion's football game.

Fans enjoy the Detroit food trucks lined up outside Ford Field Detroit Lions games.

Daisuke "Dai" Hughes co-owns Astro Coffee with his wife, Jessica Hicks.

James Cadariu is the man behind the Institute for Advanced Drinking at Great Lakes Coffee Roasting Café, where he offers a "50/50," a pint of cold-brewed coffee and Short's ControversiAle.

Stuart Litt, owner of Hygrade on Detroit's Southwest side—arguably the best corned beef Reuben sandwich in the city.

Vernor on Detroit's Southwest side.

Paczki, a traditional Polish baked good in Hamtramck.

After the Farmers Go Home:
Eastern Market at Night

Eastern Market is also home to dozens of designers, artists and galleries that have studio spaces in or near the market, as well as apartments that line the narrow streets of the market. The Red Bull House of Art is located on Winder Street and describes itself as "an art incubation project and creative environment to develop new works and innovative ideas." Inner State Gallery recently moved to the market district from former digs in Royal Oak, and the gallery/café/performance space Trinosophes on Gratiot is getting high praise from across the art world. Other businesses of interest include Robert Stanzler's Detroit Mercantile Company, which offers "provisions for the urban pioneer." Other interesting ventures include two creative print press operations: Salt + Cedar on Riopelle Street and Signal Return a few blocks away on Division Street.

So much is going on that in September, Eastern Market at night has begun to feel like market days. The sheds that normally hold farmers and food makers during the day feature at night studios, artists, workshops, performance art, fashion shows and music from groups like the fourteen-

Storefronts on Russell Street inside the Eastern Market.

piece Afrobeat orchestra. This is at an annual event called Eastern Market After Dark, part of the Detroit Design Festival. The most recent Eastern Market After Dark drew two thousand people. Eastern Market is also promoting its Third Thursday night, which will have a focus on art and design and will feature a "chandelier" made from found objects from all over the city.

Food Makers and Entrepreneurs Leading the Charge

D etroit's food entrepreneurs are at the apex of the food revolution going on in the city. Nothing seems as contagious as the excitement they have for their products, their business and the change they see happening day to day in Detroit. Detroit is a great city for nurturing small businesses: lots of available space, cheap startup costs and a ton of encouragement from the food community, the media and the public at large. At Eastern Market not long ago, one or two food makers sampled and sold their products on Saturdays. Now there are forty or more. And growth is real and happening. Detroit's McClure's Pickles went from a home kitchen operation to a twelve-thousand-square-foot plant in the city.

Detroit has a long history of people making and selling food, going back to the Wyandot Indians processing maple sap into sugar. Detroit is in a northern climate; consequently, to eat anything that might spoil all year, Detroiters preserved a good portion of their food. Common techniques included canning, salting, pickling, curing and smoking food. Detroiters have long enjoyed pickled vegetables, fish, oysters and even pickled meat; pickled passenger pigeon breast meat was not an uncommon food in the nineteenth century. Other processed food included smoked whitefish and lake trout. Jams and jellies have been produced for centuries in Detroit. The city's original sixty-foot French pear trees grew small fruit that was intended not for eating fresh but for preserving and enjoying in the off season.

As the Irish started to arrive in the 1840s, the classic "finnan haddie," a salted and smoked haddock, began to appear in Detroit restaurants.

Sausage making was done by early French Detroiters but really took off when German and Polish immigrants poured into the city after the Civil War; traditional sausages, such as bratwurst, knackwurst, blutwurst and Polish kielbasa, are still made fresh in Hamtramck. Today, sausage making is finding a new generation of craftsmen, such as Corridor Sausage at Eastern Market, which is expanding the flavors and ingredients like tomatillo, chilies, cocoa nibs, raisins, sesame, lemon grass and ginger.

It is said that the overly cooked and salty canned vegetables common on our grandmothers' dinner tables killed Detroiters' interest in eating vegetables, but today's new food entrepreneurs are putting out some incredible food in the city and generating a lot of attention.

LACTO AT THE BRINERY

David Klingenberger, the chief fermenting officer (CFO), and his crew, Clayton Smith and Gregory Hart, stay busy putting Middle Eastern–style, thinly sliced brined turnips into jars. They are mildly sour, garlicky, colored pink with beet juice and especially delicious with hummus, a Middle Eastern tradition. But other Brinery customers, such as Weber's Inn in Ann Arbor, put them on their hamburgers like pickles.

The Brinery is a concept that emerged out of the local food traditions of southeastern Michigan courtesy of David Klingenberger. As he explained, "I have been fermenting since before the turn of the century." He was born in Michigan and moved to California, where he grew up, but he knew that the Heartland (in this case Michigan) was calling. He returned and has lived and worked at Tantre Farm just outside Ann Arbor. Tantre is a well-established producer in the local organic food movement of this region. Klingenberger loves local vegetables and organic farming as much as fermenting, and the entire Brinery team comes from this same experience and philosophy. It was while working at Tantre that Klingenberger first started developing skills, knowledge and love for this ancient art of fermenting raw vegetables.

He's the kind of guy who gets very excited talking about sauerkraut. The Brinery offers about twenty different fermented products, such as Korean kimchi, pickles and tempeh—an Indonesian food made from cooked and fermented soybeans. It has been in business for five years, and each year, its volume has doubled. Its goal for the coming year is to produce forty barrels of brined vegetables.

Fermenting may be the simplest food processing known, explained Klingenberger. It was the way farmers could use up bumper crops of cabbage or cucumbers, and it kept everyone fed during cold months. The process is called lacto fermentation. It requires no refrigeration, electricity or special treatments; after all, most people fermented vegetables in their homes one hundred years ago. The Brinery puts local vegetables like carrots, beets, turnips and shredded green cabbage in large neoprene barrels and pours in the brine, which is their recipe of water, sea salt and flavorings such as garlic, fresh ginger, bay leaf, peppers, spices, herbs and seasonings. The barrels are lidded but opened slightly to allow the release of gas as the vegetables ferment. After some days, it's over. That's it. One of the Brinery's most popular products, called Storm Cloud Zapper, is a dark magenta sauerkraut made with cabbage, beets, ginger and sea salt. The sauerkraut is crunchy, lightly sour and excellent on a sausage, hotdogs and cold meats or simply eaten alone.

Adding to Klingenberger's enthusiasm is that his products are good for you. His company slogan is "Stimulating your inner economy." As his website explains, raw lacto-fermented vegetables are rich in lactobacteria, similar to yogurt, and have many health benefits, such as aiding digestion and boosting the immune system.

The Brinery products are used by restaurants in Detroit, such as Green Dot Stables, Great Lakes Coffee Roasting Company and Zingerman's, and sold throughout the region, but they can be bought at the Eastern Market in Detroit.

From Restaurants to Sausages

"Sausages are a vessel for flavor," said Will Branch, co-owner of Corridor Sausage. He and his business partner Zachery Klein began Corridor Sausage in 2009 after several years of experimenting and learning the secrets of producing great sausage and charcuteries.

Branch is thirty-three years old, a 2002 graduate of Michigan State University with a degree in English. "I figured I'd open a bookstore or video store," he laughed, reminiscing about his early career dreams.

Food has always been a part of his life: half his family is Chinese, so enjoying food and restaurants were part of his upbringing. He went to Schoolcraft Community College for professional cooking and soon worked

in New York City to learn from the best. He came back to Michigan, working in restaurants with Zachary Klein, and it was while in the restaurants that the two began making and serving their own sausage on menus.

"Long, late hours drove us out of the restaurant business," Branch said. "But actually, the sausage making hours are just as long, but it's different."

They began making sausage in Midtown Detroit—formerly known as the Cass Corridor, hence the name Corridor Sausage—but they have recently moved to Eastern Market, where they now occupy a two-story building with 8,500 square feet for making, packaging, freezing and storing their products. The new commercial location will provide plenty of space for new equipment and allow the company to quintuple its production within the next year, which is its plan.

One of the biggest learning experiences for Branch has been the extraordinary amount of regulation and requirements to produce meat products. Currently, sausages from Corridor are available through four farmers markets and about twenty-four restaurants. To sell through distributors and at retail locations, such as groceries, they need to be USDA certified. They recently received this certification after months and months of work. The label on the packages also must be approved by the USDA. The USDA's book on label regulations is 112 pages long, according to Branch; it is so complicated and arcane that it required him to hire outside "expediters," or label experts, to get through the regulatory language and comply with the USDA. In addition, the company must have an office set aside in the building for a USDA inspector, who can arrive at any time on any day of production. Branch recalled hours of communications on phrases for their label such as "Vietnamese style."

But regulations aside, their sausage is in high demand and growing beyond Detroit to Chicago and Cleveland. A big buyer of products is the restaurant at Henry Ford Museum in Dearborn. Ford Field, home of the Detroit Lions, will feature Corridor Sausage as part of an all-Detroit food section that includes Slows Bar-B-Q and Detroit microbrewed beers.

Branch added, "Right now, we are making only fresh sausage. It's enough. We make twelve varieties. The most popular is 'Vietnamese Recipe Chicken Sausage.'"

Corridor Sausage's reputation is in its high-quality protein: the meat uses no hormones and no antibiotics and is organically raised from small-scale producers. "We use no spices and no dried herbs—everything is fresh." For instance, Corridor's Vietnamese Recipe Chicken Sausage includes lemongrass, lime leaf, wild ginger, Thai chilies, shallots and cilantro.

When chefs and restaurants describe Corridor Sausage product, they use words like "bright" or "popping," meaning fresh, intense, alive and flavorful. "Other sausage companies use premixed and bagged combinations of spices, which they buy from suppliers to make Italian sausage or bratwurst. We never do that. Each ingredient is tasted separately; if a batch of juniper berries is not 'popping' with aroma and flavor, I throw them out and search for some that are," said Branch. But that's the difference between an excellent small-batch producer like Corridor and stuff most people think is good sausage. Come to Eastern Market and try some real sausage.

Or you can find it on Corridor Sausage's new food truck, the Grindhouse, which can be located throughout the area by checking online.

SUCCESS WITH GRANDMA'S PICKLE RECIPE

For many people, completing a doctoral degree in physiology from Wayne State Medical School and earning a bachelor's degree in classical guitar might seem like greater accomplishments than making pickles, but that's not how Joe McClure sees it. Perhaps Joe realizes that he and his brother, Bob (who is also a comedy writer and an actor), have accomplished something of true greatness with their business: they have made a really, really good pickle.

"We didn't apprentice," Joe said, smiling. "But I wish we had; it would have saved us a lot of time."

McClure's is actually a family affair run by the two McClure brothers—Joe, who is thirty-two, and Bob, thirty-four. Their father and mother also provide help. The pickle recipe and passion goes back to the McClure brothers' childhood. In 2006, using their great-grandmother Lala's recipe, they started McClure's Pickles after years of making pickles in their tiny Michigan kitchen with guidance from a grandfather and parents.

The business began in Brooklyn, where the McClures made pickles and delivered them in their own van throughout New York to restaurants and well-known gourmet food stores like Murray's Cheese.

To find more production space, they split the company between Brooklyn and Detroit; Bob stayed in Brooklyn to market the company, develop new products and handle the large national and international accounts, while Joe took over production in Detroit.

Joe added, "I think small-batch food products in Detroit are every bit as good as any in the country. Detroit is just smaller. Brooklyn also gets a lot of

attention from media in New York City. It's just harder to get media to come out this way. So it works out with part of the operation in Brooklyn and the other part in Detroit."

At the time they decided to make the pickles and other products in Detroit, Joe was in graduate school at Wayne State, and production was two times per week. The pickles were in demand, and the production soon expanded to four and then five days per week. They now operate a large plant of about twelve thousand square feet with eighteen people on the edge of Hamtramck. Joe processes four thousand pounds of cucumbers per day, which yields 2,500 to 3,500 jars of pickles. Pickle production begins at five o'clock in the morning and ends before lunch.

"Some companies pickle anything—vegetables, watermelon rinds, you name it. Which is fine. But we decided to limit the variety to protect the quality of that recipe. We didn't want to dilute our product line." They do make other products, like pickle relish and a very popular bloody mary mix. "It is essentially tomato juice with our pickling brine and a bit of pepper. That's it. We tried it and offered it to friends, and they said, 'You've got to sell this stuff!' so we do. We're excited because it is being sold as a mixer for fans at the Detroit Lions football games."

They also offer pickled flavored crinkle-cut potato chips, a concept they developed with the classic Detroit potato chip maker Better Made.

"Things are really going great right now. We just signed with Whole Foods across the country. Southern-based Kroger stores and Meijer is getting with us. Locally, Russell Street Deli is now selling our pickles, and the Detroit Lions food service is offering our drink mix. Of course, we sell at Eastern Market, where we meet more and more local food producers. It's really pretty exciting. It's also fun."

EATING LOCAL AT THE DETROIT LIONS GAMES

Lions fans are a puzzle. Even after decades of losing seasons and no Super Bowl playoff ever, the fans still come in droves to Ford Field on Opening Day, cheerful, smiling, optimistic and happy to be walking on Brush Street in front of the stadium on a beautiful September Sunday dressed in Honolulu blue jerseys. They also come hungry.

Food service at Ford Field is handled by the Levy Restaurants, which has placed Joe Nadir in charge of it as executive chef. One might assume

Detroit Lions' fans now consume Detroit's local food, beer and more featured at Ford Field during the games.

that the job of feeding so many people at a football game is basically logistical—making sure beer doesn't run out, catsup dispensers are full and hotdogs are hot. But Joe Nadir is from Detroit and is a real chef. He and his team at Levy were not going to settle for logistics. They decided that it was time to turn Ford Field into a celebration of Detroit's food scene.

Ben Manges, the Lions' director of communications, said, "It's a way for our fans to not only experience a Detroit football game but to experience Detroit through all these vendors and concession stands."

You can find food from Metro Detroit from the food trucks on Brush Street to Michigan's craft beers, American Coney Island, Pegasus and Billy Sims BBQ, as well as Slows Bar-B-Q on the general concourse. On the club level, you will find gelato from Zingerman's Creamery, Russell Street Deli, a second stand for Slows Bar-B-Q, Corridor Sausage, Sugar House Cocktails and bloody marys at McClure's Pickles.

Joe Nader on Detroit's Food Scene

Executive Chef Joe Nader of Levy Restaurants feeds sixty-five thousand football fans, 132 luxury suites, five mini restaurants and forty concession stands when the Detroit Lions play at Ford Field. He's a Detroiter who, like many up-and-coming young college graduates, left the city after graduating. "Everybody with talent left Detroit; there was no platform for talents in here," Nader said.

After a degree in philosophy from Eastern Michigan University, he switched to culinary training; his parents come from Italian and Lebanese heritage, which he describes as "Mediterranean," where food and dining was a crucial feature of growing up for Nader. "I think a lot of the problems families have today are linked to the fact that too many families do not sit down and share meals anymore."

He went out to California, where he constantly talked up the greatness of Detroit and its food, to the point that his exhausted friends said, "If it's so great, what are you doing here? Why don't you move back?"

"So, I did," Nader said with a smile and a shrug. And he's not regretted a moment. He worked in Ann Arbor at Sweet Lorraine's and for Main Street Venture's Gratzi, and then he hooked up with sports concessionaire Levy Restaurants and spent some time in Chicago before transferring to the Detroit Lions. He was promoted to run the operation at Ford Field as executive chef in 2006. Nader conceded that his duties at a professional football stadium are as much logistics as supervising cuisine, but he stays deeply involved in the food scene of Detroit. He finds time to run occasional pop-up restaurants with two other chefs called Detroit Three:

It's strictly for charity. I stay connected. Food is my roots…Living in Chicago really opened my eyes to their food scene. I think Chicago might be the best food city in the country right now. The difference of Detroit and Chicago is that what happens food wise in Chicago happens in the city. In Detroit, it happens in the suburbs: Ferndale, Royal Oak, Ann Arbor, Plymouth and others. Detroit has always been a great food city. We built the middle class in Detroit, and people had money to eat out. Detroit has a history of great restaurants: the London Chop House, Jimmy Schmidt's Rattlesnake Club and the Golden Mushroom to name just a few. We have a proud past and awesome traditions. But, Detroit has been all about the past. Now it's happening in the city today. Talent is staying here. Talent is coming from other parts of the country to work here. Not just food—in a lot of creative fields.

Nader and his team at the Detroit Lions have decided to introduce an all-Detroit food to spread the word. "It's not just to promote Detroit—the food and drinks that we feature are excellent. The knowledge and talent of Detroit food makers is among the best in the country. My job is easy finding these people."

He continued, "It's a small community of people who help each other out, who taste each other's stuff and support one another, who are friends and want to see everyone succeed. It's like early days of rock bands, before fame and money changes things: just regular folks doing their thing from the Woodbridge Pub, Sugar House, Phil Cooley's Slows Bar-B-Q and so many others."

Nader admitted that defining Detroit food as distinct cuisine is probably not doable, but it is the access to local sources that defines the current food movement. "You can drive twenty-five miles to reach farms and suppliers of today's great food…I'm really excited," he said, smiling.

DETROIT'S FOOD TRUCKS

Food trucks were slow to start in Detroit. In fairness, other cities have also struggled with how to deal with food trucks. The issues usually fall into two areas: first, how to maintain and monitor safe sanitation on a truck that roams from place to place, sometimes out of the jurisdiction of the city health inspectors, and second, how the city can be fair to brick and mortar restaurants, which see the food trucks as unfair competition with no commitment to their neighborhood. About two years ago, the very first efforts came up against a city bureaucracy and regulatory departments that seemed more determined to squelch the idea of mobile restaurants.

An early food truck, El Guapo, hit the streets in July 2011 after co-owner Anthony Curis spent a year working with the City of Detroit to get proper licensing, paving the way for other would-be mobile eateries to come. He claims to have made more than sixty visits to city hall to change the rules. Regulations restricted what trucks could sell—originally only hotdogs and bagged potato chips and pretzels. To protect brick and mortar restaurants, the city regulations also restricted where you could park the truck; at first, you couldn't park anywhere near crowds of people. The city health department was also unsure about the sanitation but eventually came around.

Under pressure, the city rethought its position, and now Detroit has a thriving food truck industry with more than twenty trucks roaming Detroit

Food trucks now abound in Detroit, such as the "Shimmy Shack," offering vegan dishes and parked outside Ford Field on football Sundays.

and the suburbs. Some of the common trucks found in downtown and Midtown and at the Eastern Market on Saturdays and almost any event, both public and private within a forty-mile radius, include Ned's Travel Burgers, Green Zebra Truck, Beignets 2 Go, El Guapo, Mac Shack, Grindhouse, Two Guys, Jacques Tacos, Concrete Cuisine, Mama's Tacos, Dago Joe's, Treat Dreams and a vegan truck run by Debra Levantrosser called Shimmy Shack.

Debra parks her truck outside Ford Field for Detroit Lions football games. Along with selling vegan dishes, Debra, dressed in a sweatshirt and jeans, does an occasional shimmy to attract attention. Is there a harder sell than vegan food at a pro football game? "Bill Ford [one of the owners of the Detroit Lions] is a vegan. That's one of the reasons I got this spot," she noted.

The Shimmy Shack specializes in southwest burgers, sweet potato and white potato fries and chocolate shakes. If you've never had vegan, Debra recommends the fries. "You'll be back for more."

Other truck offerings go quite a ways beyond the soggy hotdogs from a wheeled hotdog stand. El Guapo offers pork belly confit, spicy shrimp, deep-fried tofu and short ribs. Green Zebra's most popular sandwich is

bacon and tomato jam grilled cheese. Grindhouse provides chorizo poutine and Hungarian fried pizza. Mac Shack offers versions of mac and cheese, including "Cheech's Trip," "The Bacon Made Me Do It," "Dune Climber" and even deep-fried mac and cheese balls, called "Amaze Balls," served with a choice of ranch, marinara or buffalo sauces.

Beyond having good food, success depends on having your truck where hungry people can find you. This is done through continuous use of social media; for example, El Guapo has more than three thousand followers on Twitter. Others follow suit.

Will Branch of Corridor Sausage Company is a co-owner of the Grindhouse food truck, which employs seven people. "Everything is location dependent," he said. "It's a completely different business model than a restaurant. When we are gone for a few days catering a private banquet, people wonder if we've gone out of business."

Part of the appeal of the food truck is the relatively low startup costs. Dan Gearig, who was a partner of El Guapo and other food trucks, has begun a new venture, Red Beard Customs. He saw the need of custom-building food trucks for would-be vendors; Grindhouse was his first customer. Gearing has estimated that startup costs for rolling kitchens can run from $20,000 to $130,000. He estimates that about $65,000 is a good point to build a really solid food truck business. Not cheap for many, but cheaper than a full traditional restaurant kitchen, with far fewer risks. A path some startups have taken begins with a pop-up restaurant, follows with a food truck and then moves into a traditional restaurant—all the while building a menu, learning skills, growing markets and managing risk.

Others are following the opposite path. Green Dot Stables restaurant in the outskirts of Corktown is now working on its own food truck to offer its popular sliders and sides throughout the city.

Detroit's Original Food Trucks: Taco Trucks

Before Detroit had food trucks, the Southwest side had its own version of them called taco trucks. These guys are not offering deep-fried tofu skins or rabbit confit. This is real street food—cheap, a little greasy, wrapped in foil and sold in paper bags, but authentic and delicious. Detroit has about ten trucks on and off at various parking lot locales, most along or near Vernor, the narrow but lively street that runs the length of Mexicantown.

The trucks park in open parking lots and do a brisk business during lunchtime. The tacos are almost always excellent and very cheap at $1.25 each. They are small, so about four makes up a good lunch.

The El Tacquito truck is in a parking lot next to a Church's Chicken at Vernor and Military Streets. Tacos are delicious at El Tacquito, with corn tortilla (flour is offered), jalapeños, grilled onions, cilantro and a wide variety of traditional meat fillings—pollo (grilled chicken), al pastor (marinated pork) and asada (grilled beef) are all great. But in real Mexican taco fashion, you can also go native and try fillings like tripe, tongue, beef head, beef maw and more.

Detroit's Liquid Side of the Food Movement

"Naglee's Coffee House on the European Plan." The subscriber begs leave to inform the citizens of Detroit, and strangers visiting the city, that he has fitted up the U.S. Arsenal on Jefferson Avenue as a Coffee House, superior to anything of the kind ever got up in this city...Attached is a SPLENDID BAR stocked with the finest wines and liquors...a lounging and reading room on the lower floor, and a spacious SALOON upstairs...The house throughout will be kept at a temperate heat during the winter and every exertion made to contribute to the comfort of the boarders and guests.

–Detroit Free Press, *1837*

Coffee houses are where you find just about anything but coffee.

–Detroit Free Press, *1917*

The earliest French Detroiters began immediately to search out wild grapes and to plant vineyards for wine. Catawba grapes found throughout the Midwest were cultivated in Detroit. Pears were grown to make a form of beer. Of course, French Canadian fur traders had their brandy, the British preferred rum and the early Americans had whiskey. Fifty years later, Germans arrived, and soon Detroit was a beer town. Coffee shops also dotted the streets as places to relax and hang out.

Much later in 1937, Harold Borgman, owner of the now closed Pontchartrain Wine Cellars in Detroit, created a sparking wine he called "Cold Duck." Cold Duck was based on the German tradition of salvaging the wine left in opened bottles by mixing them together. Borgman included

red wine, champagne for sparkle and sugar for a slight sweetness in his recipe. The name Cold Duck was a wry translation by Borgman of the traditional German name for the concoction, Kalte Ende, or Cold End. Cold Duck was so popular that he bottled and sold it, and for some time, it was the bestselling sparkling wine in the United States.

Today's entrepreneurs are also neighborhood gathering spots, but the standards are high. Coffee drinkers, beer lovers, wine enthusiasts and connoisseurs who seek the perfect cocktail find that Detroit is as good as any city in the country to satisfy their needs. And more places are sprouting up all the time—new wineries, breweries and even whiskey distilleries are opening in Detroit.

Astro Coffee

Astro Coffee is the place people go when they want coffee that is as good, if not better, than that found in any shop in the country. It is owned and run by a young couple, Jessica Hicks and Daisuke Hughes. They know what they are doing: coffee is pour-over brewing with single-origin bean varieties from suppliers in San Francisco, Los Angeles and, yes, Anthology Coffee in Detroit.

Daisuke ("Dai"), who was raised in Ann Arbor, moved to London, England, in the early 2000s and learned the barista trade there. He also met Jessica in London, who worked with him. She's Australian. They married and moved to Australia to work in coffee shops in Sydney and increase their skills. Dai noted, "The coffee trade in Australia is really very good."

Coming back to the United States after about ten years, Dai and Jess found Corktown. After a 2009 barista stint at a local coffee shop that went broke, the couple decided to open their own place. They found a spot next to Slows Bar-B-Q on Michigan Avenue. Money was tight, so they created the coffee shop décor from wood and discarded junk that they found in alleys and odd spots around their Corktown block.

Whatever the budget was, the interior has a welcoming, rough Detroit look. Coffee, teas and other beverages are listed on chalkboards, and the same for Astro's baked goods and sandwiches, which are displayed on a counter as you enter. There are chairs and tables in front and back and counters with stools along the wall. Light comes mainly from the big windows in the front. "We wanted a place to inspire people yet make them feel comfortable. We want the shop to be a positive, uplifting experience," Dai described.

But there is more than coffee at Astro. Jess is a talented baker and makes the cakes, scones and pastries. She also makes sandwiches. The sandwiches change regularly depending on what's available; all vegetables and greens are locally sourced from Detroit's urban farms. The breads and rolls come from Zingerman's Bakery. These sandwiches and baked goods are delicious and have become popular, especially with the locals who work in the neighborhood. The sandwich most demanded is Jess's breakfast egg sandwich, which is a fried egg with an aioli sauce on a toasted Zingerman baguette—simple but addictive. Customers love the sandwich combined with Astro's "Flat White," a latte that Dai and Jess brought back with them from Sydney, Australia.

Astro Coffee offers other products, such as chocolates from Vietnam. "We sell only products we know and in some cases are connected to. The chocolate is produced in Vietnam by a brother of one of our staff."

Dai is upbeat about the direction Detroit is moving. "With more people moving to Detroit, there are a lot of businesses opening all the time. Including more coffee shops in neighborhoods. That's good, but it means we need to keep up with things. Detroit can be a stressful place to live sometimes. We want this place to feel like a home for people."

GREAT LAKES COFFEE ROASTING COMPANY

You enter the café and are struck by the beauty of the space—bright with natural light, yet there is a distinctly Detroit style in the air. Large windows that open onto Woodward Avenue; an open loft–like ambience; reclaimed wood; large, long maple tables; and metalwork on the walls are also noticeable. A chalkboard provides updates on what's available and prices. A warm, airy and friendly but tasteful café that serves coffee and in the afternoon offers craft beer and natural wines is unique in Detroit (and probably most of the United States). There has been thought put into all this.

James Cadariu is the force behind the café, a thinking man's entrepreneur. He is a lawyer, a wine and beer connoisseur, a discriminating coffee roaster and a café owner. The café was really begun to make the Great Lakes Coffee Roasting brand more visible. The café is also referred to as the Institute for Advanced Drinking (IFAD for short). Cadariu does not like to see strict lines of knowledge drawn among his interests, so he not only promotes excellent coffee, beer and wine but also regards it as "advanced

drinking." He even offers a drink he calls a "50/50," a pint of cold brewed coffee and Short's ControversiAle.

Anyone who has spent time in Europe and seen Italians getting their morning grappa or French enjoying a pastis in the late afternoon knows that cafés can be very comfortable places to enjoy all kinds of beverages. This has an interesting effect on the clientele at the Great Lakes Coffee Roasting café. Unlike typical coffeehouses near college campuses, with students sprawled out in every corner, this café does get students and business professionals in the morning, but as the afternoon approaches, the atmosphere relaxes and grows more convivial; people drinking coffee tend to do it alone, hunkered down with laptops, while beer and wine drinkers seem to come in with friends or small groups.

Cadariu's coffee roasting and the café's offerings are unmatched. The coffees are a rotating selection of Great Lakes' own freshly roasted micro-lot, single-origin coffees. The café offers both brewed and pour-over coffee, as well as an excellent cold-brewed coffee on tap. Cold-brewed coffee is steeped in cold water for a very long time to produce a complex yet mellow coffee experience. As his website reads: "We're Purists. Different coffees have different needs. So we roast each to where we feel it tastes best."

The wines Cadariu promotes are uncommon but, as with all things, thoughtfully chosen. He prefers natural wines produced by small vineyards. Natural wines use native grape varietals. Grapes are pressed and stored, but the winemaker lets natural yeasts develop the juice into wine; he or she adds nothing to it. On his website, Cadariu tells the story of his travels through central Europe, sampling the natural wines from these small vineyards. Wines are posted on a chalkboard and change frequently. The café does offer sampling, and either Cadariu himself or one of several bartenders can provide excellent advice on selecting something interesting.

Although the café does not have a kitchen, Cadariu offers locally sourced products such as pickled vegetables from the Brinery and more. Raw vegan chef Corinne Rice, who runs pop-up restaurant Chartreuse, offers a vegan Sunday brunch on a weekly basis, preparing the selection of items on site.

This is a café that brings together all the values of the new days in Detroit: highest-quality, small-batched products, locally sourced wherever possible; use of rehabilitated materials; friendliness and community spirit; charity; and an eagerness to share.

SPIRITUS LIQUORS

Detroit has a long and colorful history with beer and distilleries. In 1834, with a population under five thousand, one hundred people were licensed dealers selling liquor in Detroit; there was no estimate of the unlicensed. It was said that there was a bar for every thirteen families. A traveler from New Hampshire with a strong puritanical eye, a Mr. Parker, noted in 1834: "The streets [of Detroit] near the water are dirty, generally having mean buildings, rather too many grog shops among them, and a good deal too much noise and dissipation. The taverns are not generally under the best regulations, although they were crowded to overflowing. I stopped at the Steamboat Hotel, and I thought enough grog was sold at that bar, to satisfy any reasonable demand for the whole village."

Detroit's own Hiram Walker began distilling whiskey as a grocer on Woodward Avenue below Jefferson at the Walker Wholesale and Retail Store. He first learned how to distill cider vinegar in his grocery store in the 1830s before moving on to whiskey, producing his first barrels in 1854. In 1856, he moved with his family to the other side of the Detroit River. In three years, he had opened his distillery, calling it the Windsor Distillery and Flouring Mill (later to be Hiram Walker & Sons). Canada welcomed Walker, and he modestly named his new home Walkerville.

While the big German-based brewers synonymous with working-class Detroit, such as Stroh's and Goebels, are sadly gone, a new generation is brewing beer that is gaining national attention. In addition, Detroit is now home to several pubs and saloons where beer is sipped and analyzed, and cocktails are made with such creativity that bartenders can be taken as artists.

SUGAR HOUSE

Sugar House is next to Astro Coffee and a few doors down from Slows Bar-B-Q. It gives the feel of a dark, nineteenth-century saloon with small, candlelit tables. The bar itself is one hundred years old. Antiques and mounted buffalo heads don the brick walls. The name comes from a historic Oakland Sugar House gang that preceded Detroit's famous Purple Gang. There is no standing at Sugar House; all customers are seated at the bar or at a table. No seat available? You'll have to wait outside.

The Sugar House in Corktown, Detroit's extraordinary "craft cocktail bar."

Bartenders are dressed formally but with a historic attitude, wearing white shirts, ties and sometimes vests. They are bartenders from another time, when tending bar was a profession from which a man could be relied on to produce a repertoire of hundreds of mixed drinks. That is the inspiration at Sugar House. You can get beer, wine and the finest array of liquor anywhere in town, but it prides itself on one thing: cocktails. This is a "craft cocktail bar," like Violet Hour in Chicago and Milk and Honey in New York. You have a cocktail here, and you will likely remember it for the rest of your life.

Although they will make whatever you ask for, Sugar House cocktails are ordered off a menu. Watching the bartenders—and there are up to eight of them on busy nights—is the show, as they construct these specialty drinks that infuse as much time and energy in their making as they do flavor in their taste. But this bar uses syrups that it makes itself. Fruit juices are squeezed on site and never older than four hours. It buys three-hundred-pound blocks of ice to produce five different types of ice. (When was the last time you found the ice in your drink "interesting"?) It makes its own shrubs (once nearly forgotten bartender ingredients that are complex and bright syrups made from fruit, sugar and vinegar) and liquors that very few have heard of. But that's okay because the bartenders, like manager Dave Kwiatkowski (usually called "David K."), love explaining their art and giving guided tours through their cocktail world.

Popular libations include "Famous Last Words," mixed with Laphroaig Scotch, Bonal Gentiane, Aperol and lemon, or a "Black Palm," with Beefeater Gin, Blackberry Shrub, pineapple, Luxardo Marashino and black peppercorn.

MOTOR CITY BREWING WORKS

Motor City Brewing Works opened in 1994 and is both a brewery and a pizza joint. In both these endeavors, Motor City Brewing is outstanding. It all takes place in one of the most relaxed eateries in the city; in the summer, it is open to the street and feels more like a colorful island cantina. Light seems to pour in from all sides. You enter from the front or a side "Green Alley" doorway. All it needs is the recorded sound of crashing surf, and you need go no further, forgetting that you are in the heart of Midtown Detroit. The one thing that Motor City Brewing does not have is the flat-screen televisions, which here are not missed. The U-shaped bar where many sit to eat is coated concrete but feels and looks a bit like well-

worn stone. The second-floor offers patio tables and is equally laidback and comfortable.

Of course, the beer matters, and Motor City Brewing makes some fine suds. Its beer is unfiltered and unpasteurized for freshness and flavor. Its pale ale and Ghetto Blaster are both excellent and should be ordered, but it might be better to order the ten-dollar sampler and try the lot. The sampler for summer included pale ale, lager, Ghetto Blaster, Nut Brown Ale, Honey Porter and Summer Beer. Others include Oktoberfest Beer, which they describe as a traditional Bavarian-style Marzen beer with a ruby color, a smooth maltiness and a spicy hop character. Its Corktown Stout is an Irish-style dry stout named after the famous Detroit Irish neighborhood.

If it is liquid and fit to drink, Motor City makes it. In addition to beers, it offers tasty hard ciders; the Blueberry Perry is pear cider with blueberries. It produces five flavors of its own wine coolers. It even make some house soda pop varieties that are popular, including Rock and Rye, black cherry, orange cream, root beer and grape. The staff is friendly and happy to help through this mammoth list of possibilities.

The other side of the business is pizza. Pizzas are brick oven thin crust, freshly made and among the best in the city. The toppings at Motor City Brewing are adult-type toppings and produce some creative surprises, such as "Mary Did Have…," which includes roasted ground lamb with mint and pine nuts, topped with feta cheese, fresh tomatoes, labneh (a Middle Eastern strained yogurt) and zatar (Middle Eastern dried herb mix).

GRAND TRUNK PUB

The Grand Trunk Pub is located in what was once the Grand Trunk Rail Road's ticket station. Grand Trunk is located in the heart of downtown Detroit, one block from Campus Martius and Hart Plaza. The owners have brought back the original early 1900s architecture and the beauty of the Grand Trunk's twenty-five-foot vaulted ceilings, brass chandeliers, exposed brick walls and hardwood floors.

Built in 1879, it originally housed the Traub Brothers Jewelry store and was later converted to the Hotel Metropole Grill Room, which served lunch from 11:30 a.m. to 2:00 p.m. and advertised in the *Detroit Free Press* of 1899: "Oysters, Lobsters, Steaks and Chops—a specialty." This block on Woodward was once a high-end shopping area at the turn of the century.

The space served as the Grand Trunk ticket station from 1910 to 1934. In the era of rail travel, stations were often located outside the central city and business districts. Railroads opened what were known as city ticket offices so that businessmen and travelers could conveniently purchase their tickets without making the long trip to the station. Grand Trunk converted the jewelry store/grill room by opening up the ceiling and generally making the space reminiscent of a vaulted ceiling train station. The effect for the Grand Trunk Pub is dramatic. With its original architecture still intact, gleaming brass, dark hardwood, lamps left over from the jewelry store and antique chandeliers, it's a beautiful escape to the Detroit of more than one hundred years ago. During the warm months, you can also take a table outside and people-watch along buzzing Woodward Avenue.

Grand Trunk prides itself on supporting local vendors and distributors, buying food from local farmers at Eastern Market, as well as Better Made Potato Chips, Topor's pickles and Avalon International Bread. But as a pub, the Grand Trunk is the champion beyond equal for regional craft beers, and the craft beer industry in Michigan is as good as any in the world. This is the place to satisfy that craving. There are fifteen craft beers on tap and more than one hundred other locally brewed beers in the bottle, including Darkhorse, Saugatuck, Shorts, Dragon Mead, Milking It!, Founders, Atwater, Motor City Brew Company, Bells, New Holland and many more.

Reaching Out to Get Good Things Started

Wholesome food has become an issue in Detroit. Until recently Detroit had no supermarkets. Finding fresh vegetables was not easy and could be expensive. Those with cars drive to the suburbs to shop. Those without cars eat few vegetables. Fast-food chains thrive in Detroit. To help the city, churches, schools and the private sector are all working hard to get good food to families, to teach the importance of eating well, to provide working experience for those who want to consider food service as a career and to provide space, tools, advice and capital for entrepreneurs to make the transition from kitchen dream to real working business. Here are merely some of the many groups working to help others succeed.

"RESTORE THE MOOR"

Even by Detroit standards of bad neighborhoods, Brightmoor is seen as chronically poor, drug infested and largely an abandoned corner of Detroit. One of the biggest problems is outsiders coming into Brightmoor to illegally dump truckloads of garbage and trash on streets and driveways. But in no other neighborhood has urban farming helped people both physically and psychologically.

Until farms like the Brightmoor Farmway near Eliza Howell Park began, people never left their homes. Under the group Christian Community

Development Association, which later spawned the nonprofit organization Neighbors Building Brightmoor (NBB), a series of farms has been built up over the last seven years to draw the neighbors together. The Brightmoor Farmway, which meanders over about nine blocks through the city's northwest side, is full of gardens, orchards, sculpted landscapes, pocket parks and even goats, chickens and beehives. It is surrounded by blight, but even there, volunteers have painted abandoned homes in bright, cheerful colors.

Students tend youth gardens and sell the produce at the local farmers markets. Adults grow a wide variety of vegetables and flowers in separate gardens. Detroit City Council member James Tate, who was instrumental in pushing through urban garden legislation for Detroit, was quoted in the *Detroit Free Press*, saying, "The Brightmoor Farmway has given new identity to Brightmoor." The head of Brightmoor Farmway, Riet Schumack, said that James Tate is a real supporter, never missing their monthly meetings and coming to their parties. While NBB has worked with many outside organizations, there has been very little outside funding. From the start, people are given space to garden, seeds, advice and tools—then it is entirely up to them. They make of it what they will.

Neighbors Building Brightmoor now also has a tool bank—including riding lawn mowers and hoop houses for an extended growing season—which the whole neighborhood shares. Among all the agricultural endeavors, the neighborhood has also taken on some projects of a more artistic and recreational nature. There are semi-regular art classes for neighborhood children, as well as a playhouse and a bonfire pit, where they have fires almost every night.

But this does not come easily. Volunteers logged twenty thousand hours of time in the gardens in 2012. And it's hard work to keep it together. People can be rough, and they get into fights. Many describe the effort as "fragile." It is definitely helping Brightmoor but not restoring it.

Everyone must do their part and work together on all issues.

GOURMET UNDERGROUND DETROIT

One of the drivers of the new food movement in Detroit is the Internet and social media like Facebook and Twitter—any news food related travels fast. Gourmet Underground Detroit (GUD) is an example of a group that is using Twitter and Facebook to share information on new openings, food

demonstrations, urban farms, wine tastings, a chef in need of help, pop-up events and more. GUD was started three years ago by part-time restaurant critics Evan Hansen and Todd Abrams as a simple blog on wine, beer and drinking, but through e-mail, they began alerting a tight-knit but expanding community of any and all things in Detroit food related. As Evan Hansen explained, "The group grew and began holding wine tastings and food demonstrations such as pickling techniques." Things continued to grow until now GUD has 1,600 members on Facebook.

As Hansen described GUD, "We propagate knowledge. Hold picnics and potlucks. There's no money in it. Our focus is anything interesting that is non-mainstream food related."

More people started contributing to GUD, such as Noelle Lothamer, a journalist and blogger, and Marvin Shaouni, a Detroit photographer. Others include food makers, drink professionals, photographers and more who gather together to nurture and promote growers, startup producers, restaurants, pop-ups, winemakers or anything related to the production and enjoyment of great food in Detroit.

GUD knows what's going on in Detroit, and it has earned the respect of outsiders; the *New York Times* contacts GUD for article leads and insights on the Detroit food scene, mostly recently on the pop-up Tashmoo Biergarten.

Hansen talked about his take on the food-related activities and Detroit:

> *Detroit food scene gets a lot of attention from the national press. It's not because we have large numbers of great restaurants, like in New York or elsewhere. Absolutely not. I think it's because Detroit has had so many years of bad news [that] people are amazed that things are coming back in this way. National press, like* Martha Stewart Magazine, *have paid a lot of attention to Corktown. But other newspapers and magazines are following the food startups. Everything is wide open. We have wine tastings in abandoned churches. There is an urban farm starting in Highland Park, and people want to go check it out and show support. This is just not done in other cities.*

He sees a good future as well. "Today, a new independent startup can draw a lot of local attention, but I see as more people move into Detroit or come downtown to work the national chains will begin moving in...But that's okay. There's still tons of cheap space for inexpensive startups, and they will continue. Many of the people who have succeeded, like Phil Cooley [Slows Bar-B-Q], plan to keep going and open second and third places. So the independents will keep growing. I see a mix of both for the future."

As Gourmet Underground Detroit notes on its website: "The food revolution is here—grab your (pitch)fork and join in!"

FoodLab Detroit

Jess Daniel, twenty-eight, is the founder and current director of FoodLab in Detroit. FoodLab is a community of food entrepreneurs committed to making the possibility of good food in Detroit a sustainable reality, and it is developing a food movement that is accountable to all Detroiters. It views the food business and community as a whole ecosystem. "It started in January of 2011 when seven people sat around the kitchen table at my house and decided to tackle what they saw as a need for local leadership in the city," Daniel said.

As Daniel explained, FoodLab Detroit supports the development, growth and cooperation of locally owned socially and environmentally responsible food enterprises. FoodLab members do this by sharing info, resources and emotional support. They search for technical and financial assistance and practice a balance of financial, social and environmental goals.

FoodLab is fueled by the belief that diverse, locally owned and operated food businesses are critical elements to vibrant, resilient, healthy places. Daniel searches for food businesses that value more than profits, to create what Foodlab describes as social value. Producing, processing and serving food is powerful; food businesses have the opportunity to help address a broad array of environmental and social issues in the city of Detroit and the region. Daniel said that FoodLab is based loosely on a national outreach organization called Business Alliance for Local Living Economies (BALLE) out of Oakland, California.

Members of FoodLab convene at regularly held monthly meetings. Resources are sought, such as professional kitchen space or storefronts that allow entrepreneurs who need a chance to move their kitchen business into a professional setting, like a commercial kitchen, without the capital and risk that usually comes with it.

Daniel came to Detroit in July 2011. "I am originally from California but, after college, moved around a lot. I worked on all aspects of food, from farms to federal agency policy, while living in Washington, D.C. I came to Detroit for a couple of conferences, then a friend moved here in 2010 and I thought it might be a good place to be."

In 2011, Daniel started her own pop-up restaurant called Neighborhood Noodle, which featured southeast Asian cuisine and gave her direct experience as an entrepreneur. But her focus of late and that of the FoodLab organization has been on developing community leaders who see a broader landscape than simply starting a business, making a profit and then, if possible, giving something to charity a the end of the day.

"Detroit has a long history of this model, such as the auto industry. It is 'linear' thinking, and it hasn't worked well. Everywhere the community is complex, a broad ecosystem which requires nonlinear thinking, creativity and ingenuity. How can one combine individual vision with that of others?"

To do this, FoodLab began a "boot camp" for leaders that was developed and run by five members who are businesspeople. The results have been projects like "Detroit Kitchen Connect," which began in 2013.

The Detroit Kitchen Connect mission statement reads: "To provide reliable, accessible space for local entrepreneurs, community members and organizations to process high-quality food products in a diverse and collaborative learning environment."

"What we've seen is there is a whole segment of entrepreneurs in specialty foods that keep hitting a barrier," said Daniel. "We wanted to use what was already here to give them a space to expand their operations and be successful."

Those who pass the application process and have the necessary licensing from the state will be able to rent kitchen time by the hour. Currently, two organizations with kitchens participate: St. Peter and Paul Orthodox Church in Southwest Detroit and Matrix Human Services in the Osborn neighborhood.

For the future, Daniel sees the FoodLab staying small despite initial success. "We don't want a huge infrastructure. We want to build relationships and keep things small."

Pop-Ups, Biergartens, Hipster Bars and Blue-Collar Eats

Detroit's Pop-Ups

The idea of pop-up restaurants has been around for several years in big cities, and they began to appear in Detroit a few years ago. The pop-up concept is simple: someone with an idea for a restaurant, market, beer hall or almost anything announces a place and time for an event, usually in another bar or restaurant during a time it is not open but many times in bakeries, wine shops, museums, bars, storefronts or any space suitable. The Museum of Contemporary Art and Design (MOCAD) on Woodward in Midtown holds pop-up events in its building because it fits well with the spirit of contemporary art. Reservations are made through Twitter, Facebook, a website or e-mail so the people who attend these events usually know other people attending. While there is a spontaneous, guerrilla-style dining experience about pop-up events, they also make good business sense; it gives someone with little capital a way to test out an idea in the market, learn some real-life skills and build a loyal following without the commitment and risk of failure.

The pop-up notion has spread to other retail businesses in Detroit as well, such as bike rentals that don't require special needs in a building—just a good location.

Noelle Lothamer, the author of a popular and well-written blog on Detroit food, "Simmer Down," explained. "The 2010 Cottage Food law in Michigan really motivated a lot people to become craft producers of specialty foods. The pop-up concept really suits small producers." With a

partner, she herself began Beau Bien Fruit, a business that makes unique chutneys, mustards and jams, encouraged by the change of the Michigan law, which allows people to make processed foods in their home and then sell them just like other producers. Lothamer also created a pop-up "Holiday Food Market," which she holds in early December. She has grown it now to include twenty-five local food vendors who gather to sell their wares. "It just keeps growing every year."

One of the more successful pop-ups is Komodo Kitchen, which brings the Indonesian dining experience to Metro Detroit. Its operators are friends Gina Onyx, April Boyle and Deanne Iovan. Komodo Kitchen not only serves a meal built around foods from Indonesia, but it also immerses diners into the Indonesian culture with music, décor, incense and flavors of the island. Gina Onyx, who was born and raised in Indonesia, is the connection to Indonesian cuisine. When Komodo Kitchen arrives, it brings coolers, bags of food, utensils, glassware, plates, table linens, flowers, candles, incense and music—all the makings for a one-night gastronomical "experience." As Onyx was quoted, "When you come in, you smell Indonesia, you hear Indonesia, you see Indonesia." It was voted Best Pop-Up Restaurant by *Metro Detroit* magazine.

Some of the pop-ups in Detroit include:

- Generating a lot of press around the country, GUNS + BUTTER has held pop-up dinners from New York to Mumbai. Described by one critic as "five courses of pure Michigan," Guns + Butter is the product of gourmet chef Craig Lieckfelt and is home for now at Anthology Coffee at Pony Ride in Corktown.
- SCHNÄCK is a German pop-up restaurant featuring outstanding beers and locally produced German favorites, such as Porktown sausage.
- Operated by Jeremy Damaske and AJ Manoulian, PIE-SCI (short for Pizza Scientists) is currently making pizzas out of the Woodbridge Pub kitchen on Sunday evenings from 4:00 p.m. to 10:00 p.m. while it searches for its own building. Follow the duo on Facebook, where they usually post their menu on Sunday.
- Corinne Rice began CHARTREUSE, which offers a multicourse raw vegan pop-up supper club. Rice is a certified raw-vegan chef. Chartreuse is available for monthly dinners or monthly brunches at Great Lakes Coffee Roasting Company on Woodward Avenue in Midtown.
- DETROIT BRUNCH is a pop-up with vegan brunch options located in Midtown.

Tashmoo Biergarten

The Tashmoo Biergarten began in 2011 on an empty lot in West Village, the small neighborhood just west of historic Indian Village. On afternoons, you find crowds of people sitting at long tables and benches in a fenced-in area drinking Michigan craft beers, eating local sausage and listening to music. In the evenings, strings of twinkling lights have been wrapped into tree branches overhead to give it a comforting European feel. By the end of 2011, Tashmoo Biergarten had attracted more than 7,800 people and got the attention of the *New York Times*.

Tashmoo is named after a Native American word for "meeting place" and was also the name of a former dance hall on Harsens Island. It is the brainchild of Suzanne Vier and Aaron Wagner. Vier did graduate studies in the Czech Republic and Croatia, where biergartens are common. When she returned to the United States, she began visiting them in New York City. She saw them as relaxing, natural meeting places—in many ways, better than bars. Moving back to Detroit from New York, she and Wagner, her partner, opened up the empty space in West Village that had seen its last bar close up. Tashmoo Biergarten has been a success, and the plan is to open it for three seasons per year.

Tashmoo is open from noon to 9:00 p.m. Check the website for dates it is open.

Musicians' Haven: Cheap Beer and Pig Roasts

If you want to catch the blues or the Detroit garage band music scene or drink cans of PBR with three-dollar shots of Jameson whiskey, you need to get to Nancy Whiskey. This bar may be the oldest in Detroit, with a liquor license that dates back 110 years. Established in 1902, Nancy Whiskey survived Prohibition with its own speakeasy. In 2009, a devastating fire destroyed one of the great collections of dive bar memorabilia in the city, but after nearly a year of reconstruction, Nancy Whiskey has come back and continues going strong.

Nancy Whiskey is located north of Michigan Avenue and on the north side of I-75, which was one time Corktown but is now North Corktown (or, as some residents prefer to say, "NoCo"). The area has been decimated for so many years that it is now streets of isolated, beat-up houses amid mostly empty

space, green lawns and urban farms. But there is a strong artistic community in North Corktown. Driving around the area, you can see public art works like Jerome Ferretti's *Monumental Kitty*, a mostly brick sculpture installed in 2010 located at the north end of the pedestrian overpass that stretches over I-75 at Cochrane Street. The cat's head measures nine feet in diameter and stretches more than seven feet tall to the tips of its ears. Other sculptures dot the neighborhood, like a large fish sculpture by artist Tom Rudd that is perched in a pocket park at the corner of Cochrane and Ash Streets.

The Nancy Whiskey building looks like it once was the typical neighborhood corner brick dive bar, with a painted green front and peeling sign, but it now stands alone with a few other buildings. Nancy Whiskey is small. It has a capacity of forty-nine persons, with five televisions usually showing either the Tigers, the Lions or the Red Wings. Only a two-minute drive from the Motor City Casino, which towers nearby, and a minute more from downtown, it gets a mixed lunch crowd of casino workers, hospital personnel, businesspeople, tourists and hipsters. The menu is satisfying bar food. Delicious burgers and ham and corned beef sandwiches priced right.

But Nancy Whiskey is not really famous for lunch. This bar is considered by many as a pioneer in the Detroit music scene. On weekends, you will find live blues, and Thursday is open mic night. It's known to throw some of the best parties in Corktown. Don't miss the St. Patrick's Day parade or the Detroit Tigers' opening day. Also, the Friday night before the parade is a lively time, with the biggest and wildest crowds of the year. Tents are up in the backyard for added space. Bands also play in the open air. The open spaces of North Cork give freedom for a bar to do whatever it wants without pesky neighbors to complain. The Fourth of July has become the annual Nancy Whiskey pig roast. Two whole pigs are roasted, eleven bands play, beer flows and dancing goes on through sun, rain and, last year, hail. All for a meager five-dollar cover.

BLUE-COLLAR EATS

There are those times when you have an extreme hankering for an old-school Reuben, real corned beef or moist, steaming, peppery pastrami sandwich served in a deli/diner/restaurant unchanged for forty years. Get to Hygrade Deli. Detroit has known great corned beef and delis over the years; Lou's and Moderns are two examples. Hygrade has never claimed

to be a traditional deli, but it makes hands down the finest Reuben you will ever have.

The Hygrade Deli started fifty-five years ago at Eighteenth Street and Michigan. It was named after the anchor food operation Hygrade Food Products. The original owner, Nate Stutz, moved the deli to the present location at Michigan Avenue and West Grand Boulevard, where he sold soup and sandwiches mostly to workers from the nearby Cadillac plant. Hygrade is a Detroit eatery from the past. Plain, maybe a bit worn, noisy at lunch, busy and friendly,. Hygrade remains basically unchanged since the '70s—a genuine retro experience.

Hygrade was then bought by the Litt family in 1972 and has been run by Stuart Litt, taking over from his father in 1977. The Cadillac plant is long gone, but Hygrade stands tall like a beacon; some people will travel many a mile for Litt's outstanding Reuben and excellent soups. Litt has said that his Reuben is his most complimented product. The corned beef comes with your choice of sauerkraut or coleslaw, grilled golden brown, with the Swiss cheese melted perfectly and just the perfect amount of Russian dressing to give it that sweet-sour tang. If that weren't enough, Hygrade uses Detroit's own nationally famous Topor's pickles.

DETROIT'S OWN SQUARE DISH PIZZA

Nearly every big city in the United States claims to have its own unique pizza that is the most delicious version in existence. Detroit is no exception. Detroit's version is a square, thick-crust pizza that has a crisp, deep-dish crust; traditional toppings such as pepperoni, mushrooms and olives; and is served with the oregano-heavy marinara sauce on top. The square-shaped pizza is said to be the result of being baked not in a pizza pan but in an industrial parts tray—appropriately for a factory town.

The importance of this masterpiece is the crust. A Detroit-style pizza is noteworthy because in addition to occasionally being twice baked, it is usually baked in a well-oiled pan to a chewy, medium-well state that gives the bottom and edges of the crust a fried, crunchy texture. Pizza competitors brag about their crunchy, almost buttery corner crusts.

The origins of Detroit's square, deep-dish pizza are from Buddy's Rendezvous, which developed and began serving its signature pizza at Six Mile and Conant Street. In 1936, Buddy's existed as a "blind pig" during

The original Buddy's Pizza restaurant, Conant Street at Six Mile.

Prohibition. The owner at the time was August "Gus" Guerra. As the Buddy's history goes, in 1944, Gus turned the blind pig into a legitimate tavern, but with World War II still raging, business was suffering. He encouraged reluctant Jewish customers by offering kosher pizza. It caught on. In 1946, he decided to add Sicilian-style pizza. That really took off. The legend of Detroit's original square pizza was born. In 2009, Buddy's Detroit-style square pizza was singled out as one of the twenty-five best pizzas in America by *GQ* magazine food critic Alan Richman.

Ever-Changing Ethnic Neighborhoods

THE SOUTHWEST: MOST DIVERSE, LEAST KNOWN, BEST FOOD

Southwest Detroit is the city's most diverse area but perhaps the least well known. It has been traditionally a working-class area with men and women who filled the auto plants. It continues to be a mix of people who have included immigrants from central Europe, South America, Latin America and the Middle East. While never wealthy, the Southwest is filled with hardworking entrepreneurs, community spirit and lively street life. The area boasts more than 130 restaurants, 30 bakeries and 25 markets and specialty food stores.

It is a walkable neighborhood. Vernor Street is a narrow, two-lane urban street that wends its way like a river through the district lined most of the way with grocery stores, taquerías, churches, bakeries, tortilla factories, coffee shops, bars, drugstores, cellphone shops and whatever else make up people's everyday needs. There are some chain stores intermingled, but most businesses in the Southwest are small, independent establishments.

Mexicantown is the most well-known destination in Southwest Detroit and brings in visitors from throughout the region with its bright, gaudy buildings, colorful murals, hand-painted signs, strings of plastic chili pepper lights and, seemingly, more restaurants per square foot than anywhere on the planet. Mexicantown's borders provoke unending debates, but it does

Detroit's Southwest side, beginning with Mexicantown.

include Bagley and Vernor and begins at the old Michigan Central Station off Michigan Avenue and ends at (or includes) Clark Park.

Most Holy Redeemer's impressive architecture dominates the neighborhood from the corner of West Vernor and Junction. At one time, Most Holy Redeemer was considered the largest Catholic parish in North America and probably the largest English-speaking parish in the entire world.

The most historic church in Detroit is Ste. Anne's de Detroit Catholic. It is located at Ste. Anne's Street (Nineteenth Street) and Howard very near the Ambassador Bridge. Ste. Anne's is Detroit's oldest still functioning church, founded in 1701 two days after Cadillac arrived. It is the second-oldest Catholic church in the United States (St. Augustine's in Florida is older). The current Gothic terra-cotta structure was built in 1886, making it the eighth home of the oldest Roman Catholic parish in the nation. In addition to displaying the oldest stained glass in the city, it's also home to the remains of the cherished local hero Father Gabriel Richard, who died in 1832. It also includes the wooden altar that Father Richard used in the previous Ste. Anne's, built in 1811. While originally built for a French congregation, the dominant language at Ste. Anne's has been Spanish. The first Spanish Masses began in 1940 as the old church served people who came to Detroit to work in factories during World War II.

A lesser-known part of the Southwest area is the Hubbard Farms Historic District, located off Vernor on one of the old plots that used to be a French ribbon farm, along the Detroit River. It maintains an array of well-preserved Victorian-era homes. Currently home to a large number of Detroit's Latin American immigrants, this district has gone through many changes in its history, which dates back to Detroit's founding. In 1993, this district received its official historic district designation.

The food in the Southwest is known for its variety. They say that you have never really tasted a taco until you try them off the taco trucks that can be found throughout the area. Mexicantown, while touristy, nevertheless has some outstanding places for great Mexican food, like Casa Lupita's on Bagley. Other countries from Central America are represented in the Southwest. Dishes from Guatemala, Colombia, San Salvador and Cuba can be sampled in the district. Pupusería is an excellent Salvadoran restaurant that is well worth the trip. Off Michigan Avenue and Junction, El Barzon is one of the best restaurants in the city, combining Mexican food from the state of Pueblo with an excellent Italian menu. If it sounds odd, don't worry—both sides of the menu are done well.

Pupusería y Restaurante Salvadoreno

A pupusería sells pupusas. The pupusa from El Salvador is a thick, hand-made corn tortilla made using masa de maíz (corn flour) that is stuffed with one or more of the following: cheese (queso, usually a soft Salvadoran cheese called Quesillo), fried pork rind (chicharrón), chicken (pollo), refried beans (frijoles refritos) or queso con loroco (loroco is a vine flower bud from Central America). There is also the pupusa revuelta, with mixed ingredients, such as queso, chicharrón or bacon and frijoles. Some more creative pupuserías found in western El Salvador serve pupusas with exotic ingredients, such as shrimp, squash or local herbs.

Detroit's Pupusería is at the junction of Livernois and John Kronk Street. The décor is not why you go. You enter the building and are greeted by a large open space with a painted cement floor that may have once been a gas station garage. Walls are painted deep ocean blue, with lots of Latin American flags and velvet paintings of Salvadoran farm life. This space leads to a dining area with tables, booths, the ubiquitous

Hispanic television show and smiling families speaking Spanish. The staff at Pupusería is helpful and very friendly. The homey décor just ensures that the food must be outstanding and cheap, and it is on both counts.

Pupusas at this pupusería are delicious. Many if not most of the entrées are under three dollars. The revueltas (mix) of squash, cheese and chicken are particularly outstanding, as are the cheese with beans and pork. In El Salvador and at Detroit's Pupusería, the pupusa are served with a mildly spiced tomato dipping sauce, and they are traditionally served with curtido (a pickled cabbage relish that sometimes includes hot peppers) on the side. The Salvadorans eat pupusas by hand.

Other common ingredients include fried plantains. Chicken, pork and tamales de elote (sweet corn tamales) are wrapped in banana leaves to stay moist. Other ingredients not seen in Mexican dishes include fried or boiled yuca (cassava) mixed with chicken or pork or served alone. Unique stews are worth trying. They include shrimp stew, beef and rice and chicken and rice. Mojarra frita is a tilapia fish prepared in the traditional Salvadoran way, fried whole and served with rice salad.

HAMTRAMCK: THE BEST CITY IN DETROIT

The first thing you see as you enter Hamtramck is the enormous American Axle Detroit Plant. Driving up Holbrook, your eye catches the old Kowalski sign of a red sausage stuck on the end of a fork and an abstract black-and-white art mural on the Kowalski building. Despite the art and murals, this is a working man's neighborhood. The memorable architecture is Catholic churches. (Detroit was once called the "City of Churches.") Hamtramck is loaded with beautiful churches, like St. Florans, with its American flags and Polish banners, nestled in its residential neighborhood.

The city is considered the best in the state of Michigan for walking, according to Hamtramck's website. Narrow side streets are jammed with two-story flats, so close together you've got to turn sideways to get to your backyard, which is the size of a bathroom mat. It's lively with moms and kids, elderly people, busy traffic on Joseph Campau and cars parked bumper to bumper on the street; everything feels jammed together in Hamtramck. Main thoroughfares offer a weird mix of traditional if not tired-looking storefronts, gas stations, common businesses, workingmen's

shops and beer bars. But recently, this mix includes Bosnians, exotic and colorful Bangladesh clothing shops, Yemeni grocers selling spices and gigantic bags of rice, artists and hipsters. While you are admiring an imposing Polish Catholic church, you hear the midday Muslim call to prayer. As of the 2010 American Community Survey, 14.5 percent of Hamtramck's population is of Polish origin (in 1970, it was 90 percent Polish). The Hamtramck school system deals with children speaking twenty-eight different languages; in two-thirds of the homes, English is not the primary language. Like the neighborhood churches, Hamtramck High School is wedged among small side streets. There's no sweeping grassy lawn or football stadium; the walls of the building come within two feet of the sidewalk. The beauty of all this is that somehow it works happily in Hamtramck.

However, the city was founded not by Poles but by German farmers and named after a French Canadian military leader who fought in the Revolutionary War, John Francis Hamtramck. In the early days, Hamtramck was in the country, far from the bustling city of Detroit. It was far enough away from the Detroit police that farmers complained about the violence, drunkenness and "cocking mains" (cockfights) at the roadhouses. In 1914, things changed when the Dodge brothers, John and Horace, opened an automotive forged parts plant on the south side of Hamtramck at the Detroit border. By the 1920s, the Dodge brothers were building entire cars. The plant grew until it eventually became the gargantuan Dodge Main, with thirty-three buildings and 5 million square feet, taking up sixty-seven acres of land. At lunch or at fifteen-minute breaks, assembly line workers would run from Dodge Main across Joseph Campau Avenue to the bars, where bartenders had lines of shots and beers already set up for them. The city put up a traffic light to try and reduce the number of men hit by cars as they raced across the street.

The plant closed in 1980 after seventy years of production. But by 1930, Hamtramck had a population of more than fifty-six thousand, mostly Polish. There were so many Poles working at Dodge Main that the working language at the plant was Polish.

Eventually, Detroit's borders pushed out and engulfed the city, so that now Hamtramck has become an island surrounded on all sides by Detroit.

Hamtramck has its kitschy side as well. Nowhere is this more visible than in the "Hamtramck Disneyland." The amazing spectacle is located in an alley off Klinger Street. To get there, take Joseph Campau Avenue north, then turn right on Commer and then down the alley between

Sobieski and Klinger Streets. It is in the alley that you see a sign that reads, "This way visitor to Disneyland." What you experience is a giant collage of colorful pinwheels, flags, rockets and stuff beyond words, mounted on top of two garages—one person said that it is all reminiscent of that old board game Mousetrap. It is getting a bit tattered, but it is still worth seeing. It was built by a retired Ukrainian autoworker, Dmytro Szylak, who is now in his nineties.

For a night out, you could visit Planet Ant Theatre. It's not Polish, but it has been a staple in Detroit's improv comedy scene. Planet Ant Theatre boasts some of the finest talent in the Midwest. The theater is a rehabbed Hamtramck row house across from the Hamtramck Public Library. The place is intimate (very small) and cheap; seats to a brilliant show with some serious talent are only five to fifteen dollars. You can also bring your own booze.

You can immerse yourself in Polish culture in places like the Polish Art Center, originally founded in 1958 and owned by Raymond and Joan Bittner since 1974. (In fact, Joan is not Polish but Scottish. Poland is her adopted home, she says.) Located on Joseph Campau in downtown Hamtramck, it is a small Polish import shop loaded with beautiful Polish folk art from all corners of the country. Raymond tours the Polish regions every year and has made friendships with the artists, bringing home their beautiful work. The couple also offers classes on some of the Polish cultural traditions.

While the people of Polish descent have declined in numbers in the city, the culture still dominates. The food reflects that demographic change, becoming more diverse. Of course, there are Polish favorites, like restaurants Polish Village and its neighbor Polonia, and Polish markets like Srodek's, but now Yemeni food shops line Conant Street. Somehow it all works out.

EATING AT YOUR POLISH GRANDMA'S

Eating in Hamtramck's famous restaurants—either Polish Village Café or neighboring restaurant Polonia—is like a step back not only to Poland but also to old Detroit, before hot sauce and deep frying, dinner served straight-forward and with large portions, brought out hot and sometimes still served by no-nonsense Polish ladies. And all very good.

The Polish Village Café in Hamtramck.

Polish Village began in 1925, when a man named Pilecki built a hotel for men only with a rathskeller at 2990 Yemans Street. His customers were Polish immigrant men who worked at one of several Detroit factories, such as Dodge Main or Fisher Body. In the 1940s and '50s, Hamtramck's population surged to more than fifty thousand as more immigrants arrived. Hamtramck's main thoroughfare, Joseph Campau Street, was then the

second-busiest shopping district in the nation. In 1974, Ted Wietrzykowski bought and renovated the rathskeller to open the Polish Village Café. The tradition of welcoming immigrants and their descendants continues to this day. Carolyn Wietrzykowski now manages the famous restaurant with some of the original cooks in the kitchen, making what Carolyn describes as "food your grandmother served"—if she were Polish.

Polish Village is the Detroit that many grew up with—Americanized European-style décor and a beautiful bar that looks like hundreds of bars that were once in fixed-up basement rec rooms throughout Detroit, with dark wood paneling, Christmas lights strung up during the holidays, Victorian-style stained glass behind the bar and rows of bottles of American and Polish liquors.

Appetizers are huge, made with pork, mushrooms and vegetables. Savory pancakes are commonly served. Of course, the go-to appetizer standard is the pierogi sampler. Pierogi are all made locally in Hamtramck and include fillings of cheese, sauerkraut, potato and two dessert versions with sweetened cheese and blueberry and strawberry fillings.

Polish soups are also unique. Traditional Polish soups include dill pickle soup, which is fragrant with dill pickles but creamy and satisfying. The czarnina, or duck blood soup, is a surprising sweet soup made with duck's blood but also vinegar and sugar, as well as cut-up plum to add fruity sweetness and tiny noodles.

Main courses include Polski Talerz (Polish Plate), a "Taste of Poland," with stuffed cabbage, pierogi, kielbasa, sauerkraut and mashed potatoes in gravy. Another favorite is the Surowa Kielbasa with Sousie Piwnym—fresh Kielbasa in a beer sauce. Or you might try an old-time classic Detroit favorite, City Chicken, which at Polish Village Café is skewers of pork braised in a delicious gravy-style sauce.

BAKERS AND BUTCHERS: HAMTRAMCK'S CULTURAL FOUNDATION

New Palace Bakery has been in Hamtramck for more than one hundred years. It is a small bakery with a faded awning on Joseph Campau Street. Inside the bakery, it is unassuming, with wood-paneled walls, American and Polish flags, framed photographs, yellowed newspaper clippings and handwritten signs here and there telling customers what's available and

the prices. It is run by manager Vicky Ognarovich and three other ladies except during holidays, when they bring in about one hundred people to handle lines of customers that run outside the bakery and down Joseph Campau—there's a two-hour wait at Christmas, on Fat Tuesday before the start of Lent and at Easter.

This is the place to come for every Polish treat you have ever heard of: angel wings, flat flying saucers, French sticks, lemon shorts, chocolate rolled cakes with crème, poppy seed roll cakes, little cookies called "chocolate boys" or "vanilla boys," coconut snowballs, almond rolls, lemon tarts and kolackzi—just some of the endless varieties in glass cases that surround the shop. Its biggest seller (excluding paczki, pronounced *punch-key*) are angel wings that are piled high in a bin. They are sweetened crusts with powdered sugar—light and delicious, especially with espresso. The French donuts with custard are also luxurious treats. They make custom cakes, coffeecakes and Dutch fruit pies.

Many treats are specially made only during holidays, such as honey rum bapka, a poppy seed almond cake and mazurka at Christmas—as well as, of course, the famous paczki on Fat Tuesday. These are deep-fried jelly-filled donuts. You can buy them any time of the year at hundreds of shops throughout Detroit; however, that is not how it's done at New Palace Bakery. On Fat Tuesday, when it's typically below freezing outside, one to two hundred people line up around the block to buy paczki, which means an hour wait to get in the store. Paczki Day, as it is called by some, also attracts one or two local television news vans, high school bands and cheerleaders, and just buying paczki has become an annual celebration. But the people at New Palace Bakery manning the counters stay friendly and keep things moving along.

Even if you don't eat Polish baked goods that have been freshly baked, you should buy some to take on your car ride home. You will be amazed at how freshly baked goods makes your car smell wonderful and your look on life improve.

SRODEK'S POLISH AND EUROPEAN DELICATESSEN

Like many of Detroit's sources for great food, there is not a lot of concern placed on the appearance of the shop. Srodek's follows this pattern. It is a small Polish deli with a bright-red awning on Joseph Campau. Srodek's

has a reputation that is second to none, but walking into the deli, you find a small shop, really no different than any deli: glass cases, chrome metal shelving and linoleum floor. Srodek's is owned and run by sausage makers Joe Srodek and his son, Rodney, the third generation, who arguably make the best fresh and smoked sausage in Detroit. Who cares what the shop looks like when you make so many great Polish classics? Not the Polonia of Detroit and the suburbs. Come for the food, forget the Feng shui.

If you have never had real deal Polish kielbasa, that alone is worth a trip to Srodek's. You may also want to try Hungarian pork sausage. The real kielbasa are big, not like the supermarket stuff. When asked the best way to cook them, a Polish customer quickly said, "You boil them. Fifteen minutes. Then cut them up and put them in white borsht."

"Are they good on the grill? What about grilling them?"

She gave me a puzzled look, "You could…"

"Any other way?"

"No. Boil only!"

Sausages are smoked behind the shop using apple and cherry wood from Wisconsin. Try the chunk veal and pork smoked kielbasa. Incredible. Also, the spot smokes a large variety of hunter's sausages. Other meat products worth trying are minced pigs' feet meat in jelly or a spicy headcheese. Srodek's also makes pierogi on site. It produces about thirty varieties. Along with standard fillings of potato and sauerkraut, it offers some fun alternatives like "American cheeseburger," as well as traditional dessert fillings.

Soups are also made at Strodek's. Try some Polish classics, like dill pickle, duck blood, tripe and sorrel soups. It also makes its own sauerkraut (which can be bought by the barrel), honey, potato dumplings and some of the baked goods.

Along with food made on site, take a walk through the shop and try some of the Polish condiments, beets, soup packets, sauce packets, mushrooms, jams, coffee, cookies, gingerbread cookies, candy (Polish candy is one of the bestselling items), fruit syrups, juices and Polish and Ukrainian beer. Wash it all down with a six-pack of Zywiec.

A word of caution: if you decide to visit near Christmastime or Easter week, prepare for long lines and a two-hour wait.

BANGLADESHI DINNERS ON CONANT STREET

So many Bangladeshi call Hamtramck home that Conant Street is now referred to by some as "Bangladesh Avenue." Aladdin Sweets and Café opened in 1998 next door to a Bangladeshi grocery store. When you walk in, there is a deli counter filled with premade goods for takeout.

This is one of those places that you go to for the food. The dining room has been decorated, but you sit and are served a pitcher of water, Styrofoam cups, paper napkins and plastic forks. The place on Saturday night is hopping, with diners and people coming in and out for carryout. This is a locals' place: the English, when you hear it, is heavily accented, and locals know best. Be warned: if you have never had spicy Indian Subcontinent food, it can be extremely hot. If you do not like spicy food, make sure to let your server know this.

Bangladeshi food is your chance to try lamb, goat, chicken, beef, seafood and vegetarian dishes. Your entrée will be served with either rice or naan—the round, flat bread freshly baked on the sides of a clay oven. Naan is warm, chewy and delicious. When served with basmati rice, it makes a perfect meal.

Aladdin's, a Bangladeshi restaurant in Hamtramck.

"Bangladesh Street" in Hamtramck. The area has had so many immigrants move to the city that the Hamtramck school system deals with children speaking twenty-eight different languages.

Goat dishes, such as the goat korma, are usually braised for a few hours, which makes them extremely tender and flavorful. The braising sauce uses yogurt, which when served is warm and rich with a slight spice for heat. Lamb dishes are delicious typically served as shish kabobs. There are also many chicken and seafood dishes.

Bangladesh is famous for its desserts and sweets. Many Bangladeshi restaurants or groceries are filled with choices; some are wrapped in leaves or soaked in caramelized sugar. They may not be to everyone's taste, but try a few as one way to end a great meal.

Conclusion

One of the impressions you get in Detroit is that young people dominate the food revolution. That could be due to the fact that starting a small business based on food or beverage can be done on the cheap in Detroit, and this might appeal to younger entrepreneurs with limited funds; making sauerkraut requires only a clean space with minimal equipment. There's seldom expensive machinery that requires lots of capital and experience to start working. But it's clearly more than that; a lot of other occupations are cheap to get into.

What distinguishes the Detroit food movement is passion and vision—wanting to make an old, ailing city their own and a better place. Many others of all ages love Detroit, but those in the food movement see it differently and have the energy and desire to transform it. Their vision has become infectious, and changes really are happening.

In Detroit, the new food people, young and old, are idealists. Some are searching for the exquisite culinary experience that will last a lifetime—an incredible cocktail, the new taste of that sausage, a dessert remembered forever, an evening under the stars with friends or the aroma of slow-drip coffee.

Others form a different kind of idealist. They believe in the power of food to heal, make people come together, help others and make a neighborhood whole and healthy. Bakers can become rhapsodic over a warm, freshly baked loaf of bread, so simple and yet so powerful in its ability to change people. Urban farmers spend hours and hours growing organic vegetables out of rubble and abandoned streets—a living metaphor of renewal and

new beginnings. Some people are using food as a way to rebuild a city by providing wholesome food, training, jobs or a chance to start their dreams of business to those who have seen none.

Some of these idealists are on a search for a past Detroit by making food they grew up with and loved. Some are finding and sharing their family heritage through cooking and bringing it to customers. Others are going to the roots of something simple, like pizza, and learning how it was originally made by hand in Italy—the tools, the care and the knowledge of making something as it was originally conceived. You hear all of them say, "You've got to taste this!"

Many of these pioneers are college graduates. Some have traveled the world and tasted authentic food of other countries. They have studied philosophy, art, literature, classical music and more, so why do they end up in Detroit in the food business? Asking this question brings out different answers. First, it's a business that is challenging and sometimes exciting. It is their own and an expression of themselves, from the taste of the real gelato to the label on the jar. They are also part of a family of like-minded people. Among the food people in Detroit, there is competition, but it is a positive competition—everyone wants everyone to succeed and to bring great food and experiences to Detroit. Ultimately, it is Detroit. It is a city that needs their help, and they know this. Many come to the city from elsewhere. They are discovering the real Detroit—the legendary buildings, the reinvigorated Detroit River, the fascinating history and the seemingly intractable problems; above all, it is about the people and the community.

They believe that good communities begin with good food.

Index

About the Author

B ILL LOOMIS was born in Detroit and lived in the neighborhood of North Rosedale Park. He has a BA in literature from the University of Michigan and did graduate work in television at New York University. His writing has appeared in such publications as the *New York Times*, *Quality* magazine, *Michigan History* and the *Detroit News*. *Detroit Food* is Mr. Loomis's second book. He sees exciting changes in the city and regularly gives tours of Detroit to visitors both local and international. An excellent speaker, Mr. Loomis is frequently invited to talk about the city and its future.

Photo by Barney Klein.

About the Photographer

A NKUR DHOLAKIA is a multimedia photojournalist based in Portland, Oregon. Previously, Ankur was a multimedia producer/staff photographer at the *Detroit News* for ten years, covering a wide variety of assignments throughout Metro Detroit and Michigan for the paper. His work was frequently picked up by other publications and the wire services. Ankur served in the U.S. Army as a ground surveillance systems operator stationed in Alaska. He also served as a public affairs specialist/journalist in the Alaska and Michigan National Guard. Ankur's two favorite subjects to shoot are his cat, Clancy, and

ice hockey. When he is not taking pictures, he is enjoying his free time, checking up on the stock market and spending time with his wife. Let Ankur tell your story. Please visit his website aldphotography.com or follow him on Twitter @photoscribbler.

Visit us at
www.historypress.net
..

This title is also available as an e-book